Master Album of Pictorial Calligraphy and Scrollwork

An Antique Copybook Rediscovered

Baldri van Horicke

Dover Publications, Inc., New York

Published in Canada by General Publishing Company, Ltd., 30 Lesmill
Road, Don Mills, Toronto, Ontario.
Published in the United Kingdom by Constable and Company, Ltd.

This Dover edition, first published in 1985, reproduces in its entirety, in
somewhat altered order, the hitherto unpublished manuscript "Livre
contenant plusieurs sortes descritures avecq divers traicts faict - Invente et
mis en lumiere. Par Baldri van Horicke, maistre a escrire des Pages de
leurs Alt:zes Ser:mes de glorieuse memoire en Bruxelles," with text vari-
ously in French, Spanish, Latin, and Dutch, executed in Brussels,
c. 1633. The Publisher's Note and the translation of the original title page
have been prepared specially for this edition.
The publisher is grateful to Irving Zucker for making the original
manuscript available for reproduction.

Manufactured in the United States of America Dover Publications,
Inc., 31 East 2nd Street, Mineola, N.Y. 11501

Library of Congress Cataloging-in-Publication Data

Horicke, Baudouin van, fl. ca. 1636.
Master album of pictorial calligraphy and scrollwork.

Introd. in English.
"Reproduces in its entirety . . . the hitherto unpublished manuscript
'Livre contenant plusieurs sortes descritures avecq divers traicts faict,
invente et mis en lumiere par Baldri van Horicke . . .' with text variously
in French, Spanish, Latin, and Dutch, executed in Brussels, c. 1633"—
P. c.
1. Calligraphy—Early works to 1800. 2. Scrolls (Decorative arts)—
Early works to 1800. I. Title.
NK3631.H67A4 1985 745.6'197'0924 85-10409
ISBN 0-486-24974-3

PUBLISHER'S NOTE

This book reproduces in its entirety an unpublished calligraphy copybook prepared, but apparently never engraved or published, by Baldri (or Baudouin) van Horicke, about 1633. Little biographical information is available on Horicke, but we do know from the title page of the manuscript that he was an official writing master and instructor at the court of the Spanish Hapsburg archdukes in Brussels. One other work of Horicke's can also be identified with certainty, from the catalog of the collection of P. Wouters (canon of Lierre, Antwerp), which was auctioned off in Brussels in 1797. The catalog mentions a folio volume of sixty-four leaves, including twenty-five equestrian portrait drawings in pen of the Netherlandish princes from Philip the Bold to Ferdinand of Austria, thirty leaves of biographies of these princes, and nine leaves of figurative ornament and highly decorated calligraphy.

In both works, Horicke's calligraphy goes far beyond the formation of letters; the creation of elaborate ornamental scrollwork and pictorial figures came to dominate the process of writing. As the art historian Peter Jessen wrote, "Creative people feel the urge to go beyond the purely necessary, beyond mere legibility, and to arrange the letters, words, lines and sections into a surface pattern, to enrich them with linear flourishes, the overflow of their high spirits. Writing becomes art." (See Peter Jessen, *Masterpieces of Calligraphy: 261 Examples, 1500–1800*, Dover 24100-9.)

Calligraphy of this level of sophistication enjoyed an especially rich flowering in the Low Countries around 1600, reaching the apex of what was already a great tradition. Flemish calligraphers in Antwerp and Brussels had long taught the ornamental scripts that transformed writing into art. Whether for government and the legal profession (in certificates, journeymen's indentures, treaties and the like), for merchants (in contracts and invoices) or for the personal use of members of the educated classes (in letters, albums and holiday messages), calligraphy was a highly prized and highly cultivated skill.

To increase their skill, practitioners made frequent use of copybooks, printed collections of specimens and models for emulation. Over eight hundred such copybooks are known to have appeared between 1500 and 1800, although they are now exceedingly rare. The first copybooks began to be printed in the early sixteenth century, in woodcut. But this relatively clumsy medium was not well suited to the delicate, fluent lines and swirls of the more elaborate, and more highly prized, forms. Inevitably copperplate engraving superseded woodcut, being able to reproduce more faithfully the free-swinging pen strokes and varying thicknesses of handwriting.

We know from the wording "mise en lumière" in the original title page of Horicke's manuscript that he intended his work to be published in such form, but it seems never to have actually been engraved or printed; at any rate, no publication has been traced. Yet this loss turns into a great advantage for the modern reader, since the present volume has had to be reproduced directly from the original manuscript, instead of from a copperplate edition. Direct reproduction is an advantage because even the copperplate engraving process, though superior to woodcut, nonetheless involved a potential loss of quality, almost inevitable when translating the fluid, unfettered movement of the hand that wields the pen into the mechanical, constrained action of the engraver's burin. The present edition also avoids the uneven printing that could have afflicted copies made from plates. The work is here presented just as it came from the master's pen.

These technical advantages would count for little, however, were the calligraphy itself not of such extraordinary quality. The copybook here published for the first time represents a unique find—an all but unknown major work, including dozens of dazzlingly elaborate tours de force. For Horicke was gifted with an exceptional sense of linear inventiveness, an extravagant, pictorial imagination that will remind many of the work of the great master Jan van der Velde, especially the *Spieghel der Schrijfkonste* (1605). There are, to be sure, differences between them: Horicke rarely applied the framing devices that help give van der Velde's pages their strong sense of unity; Horicke was inclined toward more local elaboration. Yet in his splendor of execution, in the bold "striking" of his fanciful figures and unlikely beasts, in the sheer command of hand that makes his creations not mere displays of technique but manifestations of virtuoso draftsmanship, Horicke is fully worthy of comparison with his great predecessor.

Master Album of
Pictorial Calligraphy
and Scrollwork

Translation of the Original Title Page

(The original title page is reproduced as
page one of this edition.)

Top, in French: Book containing several kinds of script with
various ornaments, drawn, designed and published by Bal-
dri van Horicke, writing master to the pages of their Royal
Highnesses of glorious memory in Brussels.

Bottom, in Spanish: Book in which will be seen various styles
of script ornamented with extensive scrollwork, drawn,
designed and published by Balderico de Horique, writing
master to the pages of their Royal Highnesses of glorious
memory in Brussels.

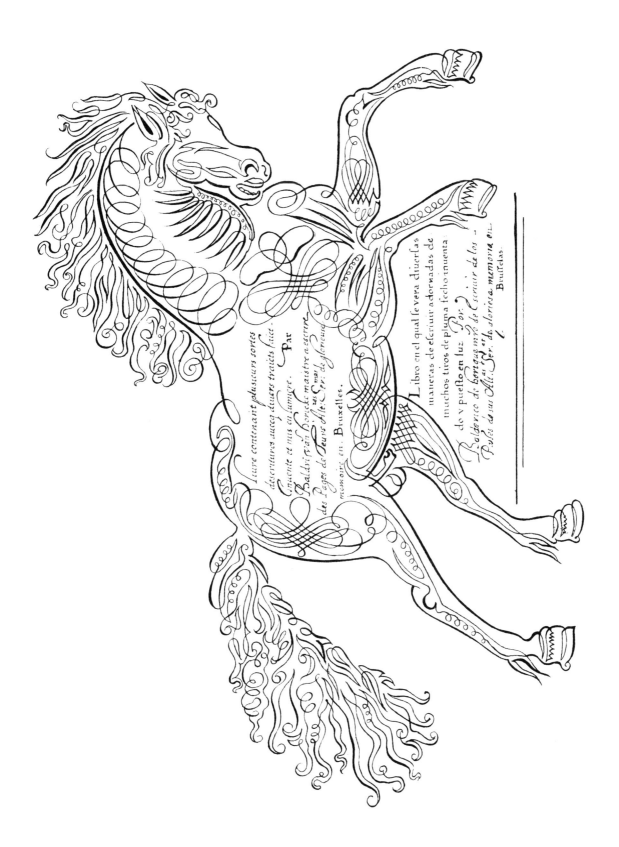

Liure contenant plusicurs sortes
descrittures auecq diuers traicts faict.
Grauente et mis en lumiere. Par
Baldriston Boriske maistre a escrire
des Pages de leurs Alte. Ser. mas. de glorieuse
memoire en Bruxelles.

Libro en el qual se vera diuerlas
maneras de escriuir adornadas de
muchos tiros de pluma fecho inuenta
do y puesto en luz Por.
Baldeuico di borrigue mro de escriuir de los
Pajes de sus Alt. Ser. de gloriosa memoria en.
Brusselas.

1

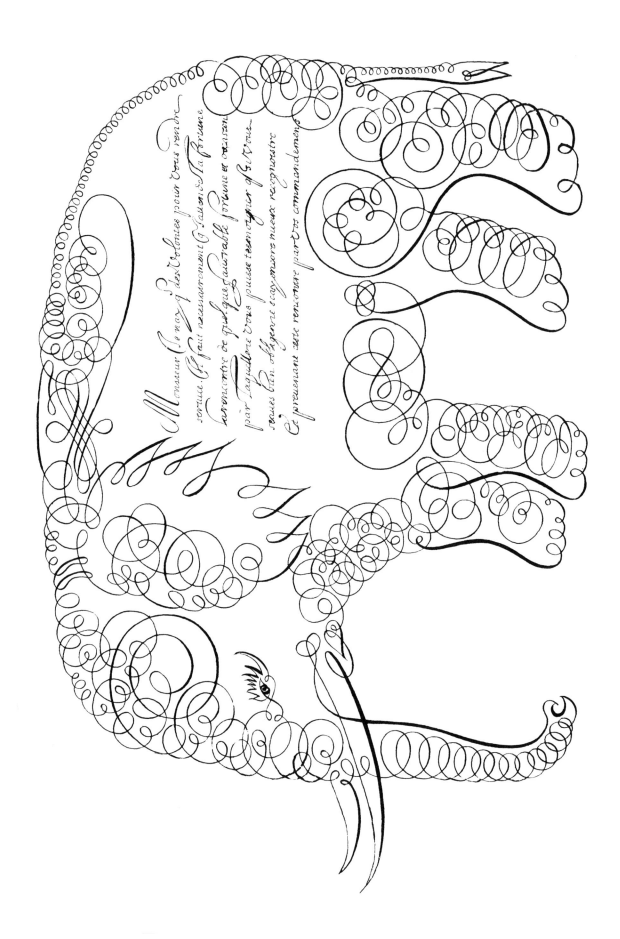

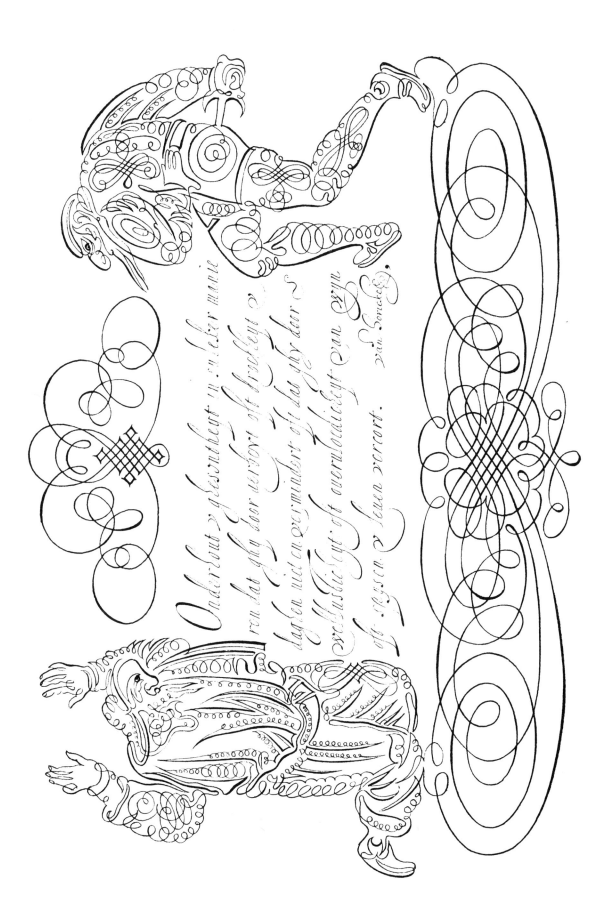

3

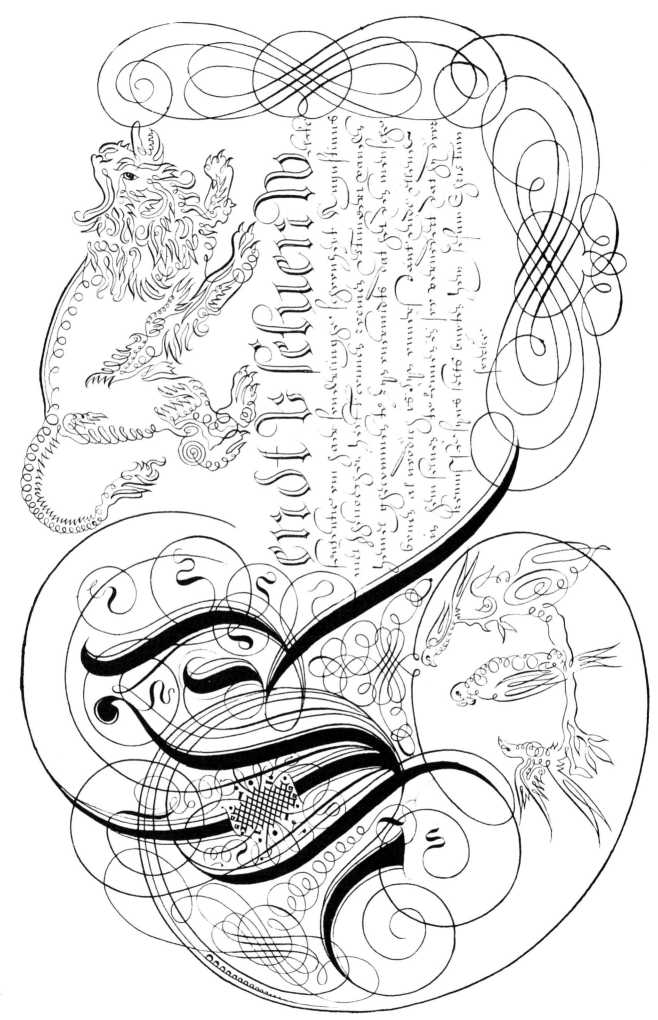

4

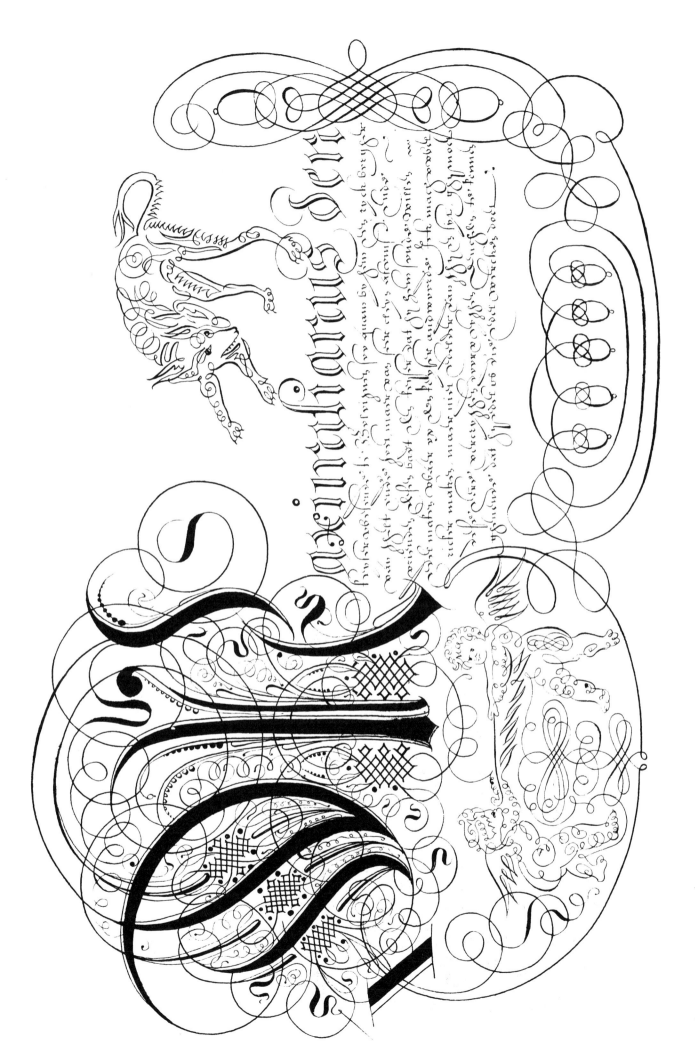

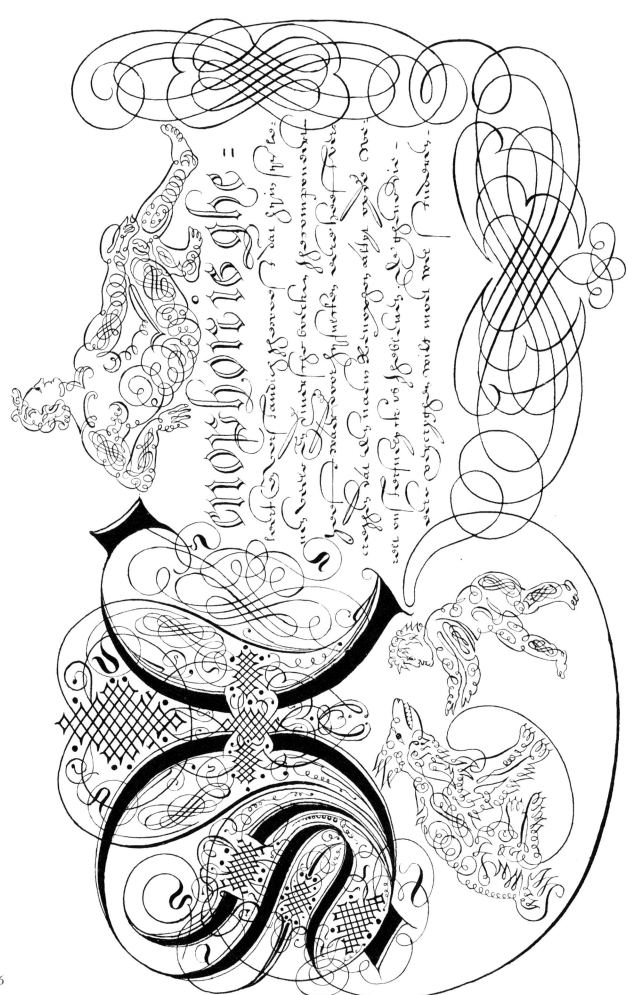

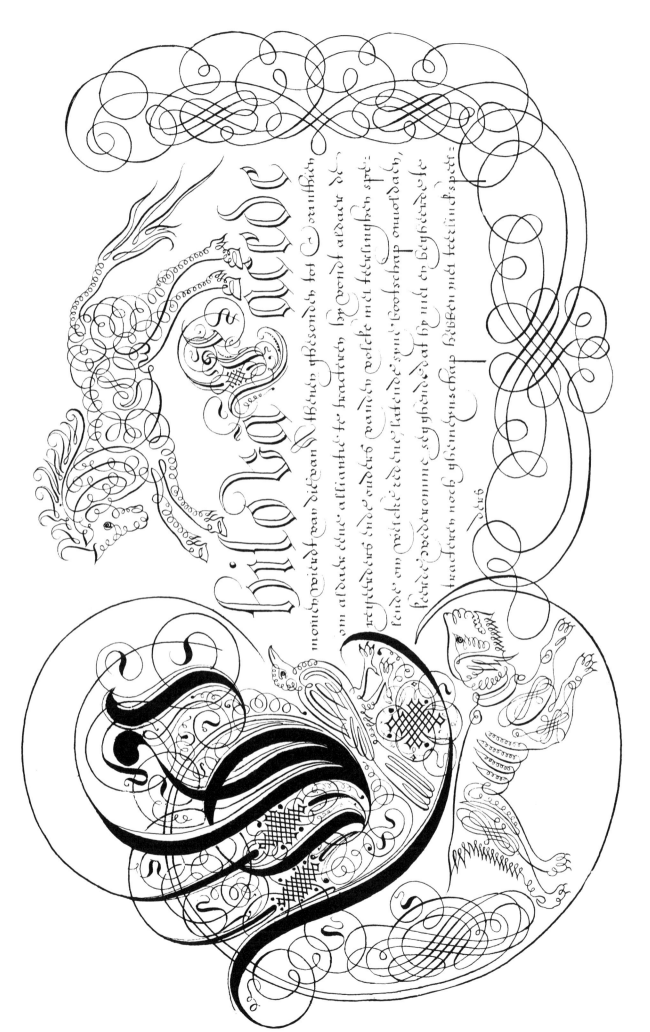

7

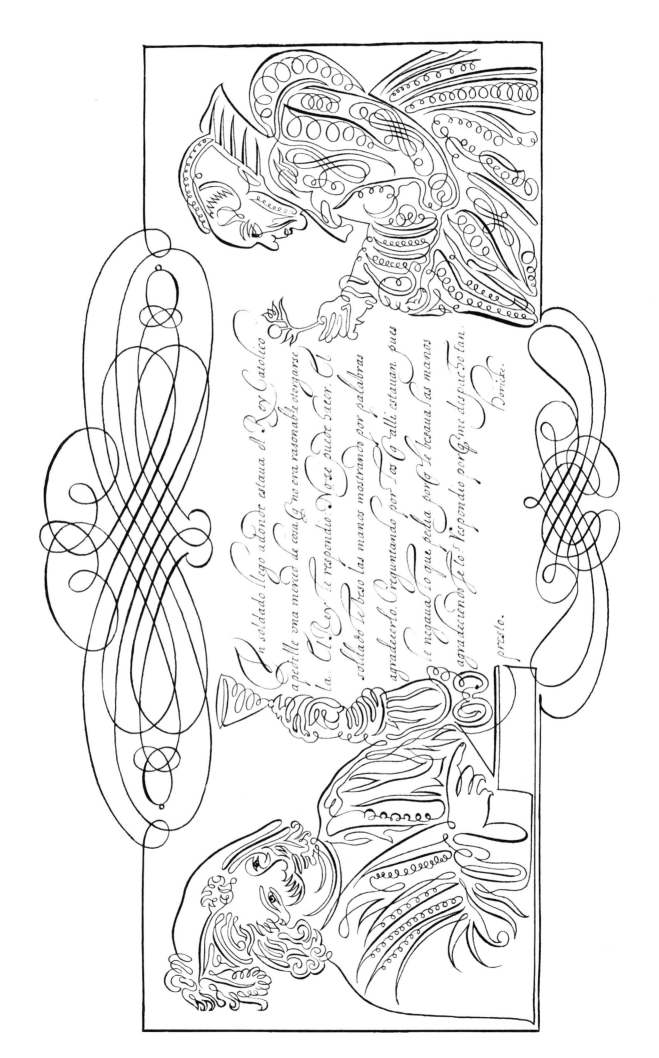

Un soldado llego adonde estaua el Rey Catolico
a pedille una merced de cosa q̃ era rasonable otorgarse
la. El Rey le respondio. No se puede hacer. El
soldado le beso las manos mostrando por palabras
agradecerlo. Preguntando por los q̃ alli estauan. pues
te negaua lo que pedia por q̃ le besaua las manos
agradeciendo se lo. respondio por q̃ me despidio tan.
presto.

Boricke.

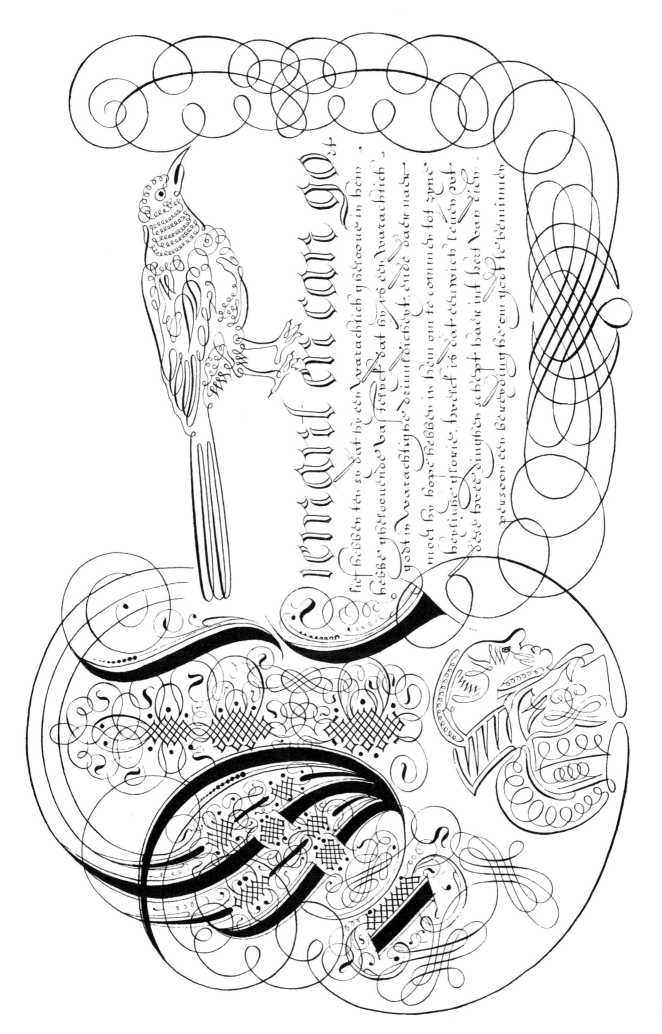

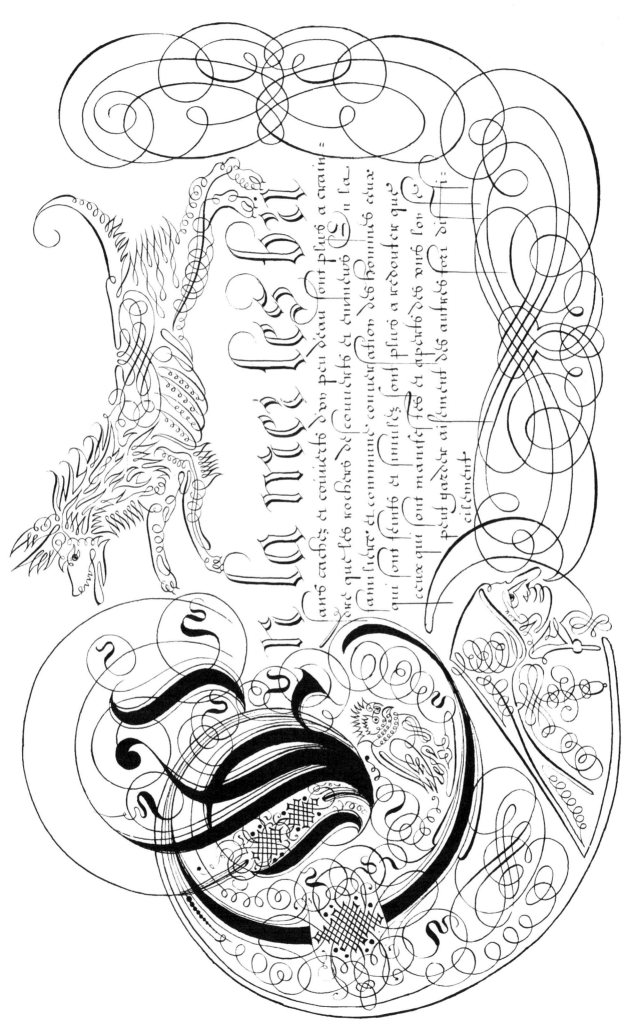

Sans cachés et couuerts son peu scau sont plus a crain
que que les roches de couuertes et cuincures en la
fault sichie et commune, conuocation des hommes ceux
qui sont seuts et muultz sont plus a redouter que
ceux qui sont manifestes et apertes vnis son
peut garder aisement des autres sort diffi.
cilement

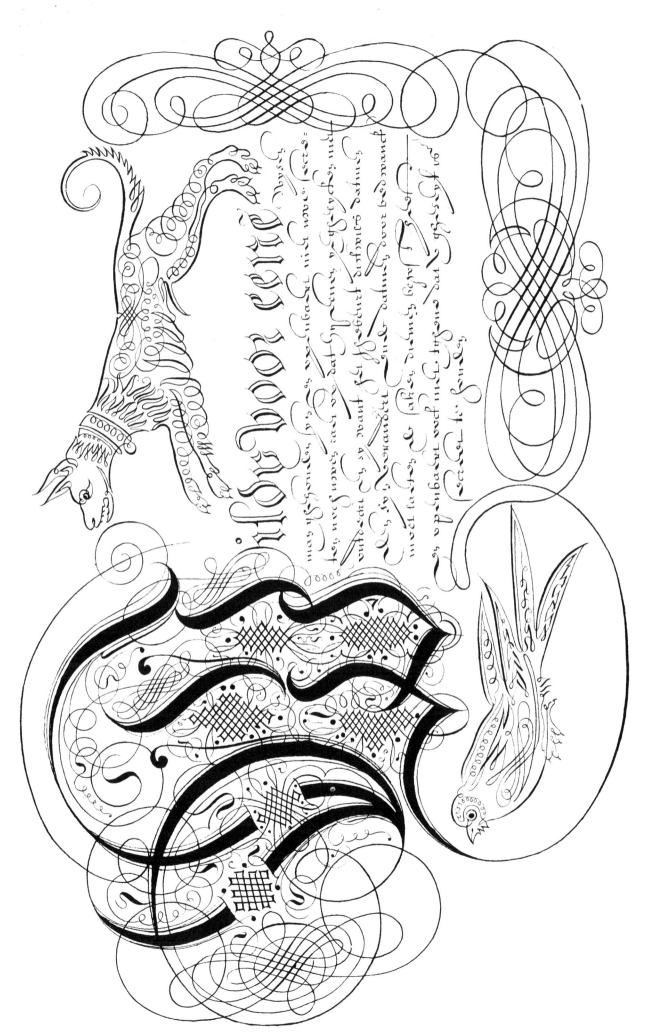

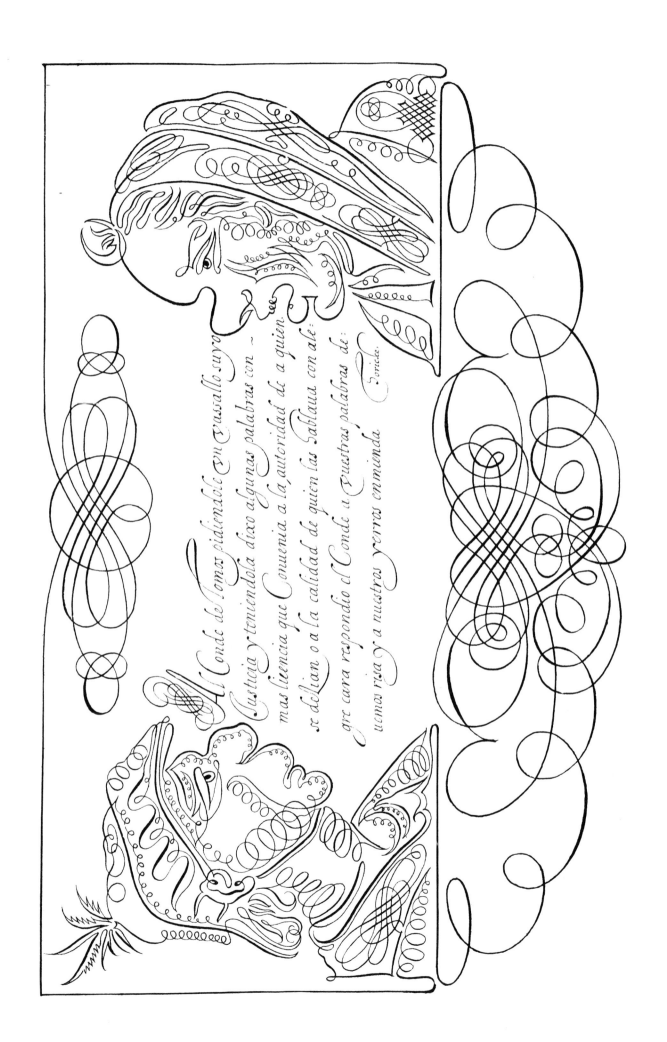

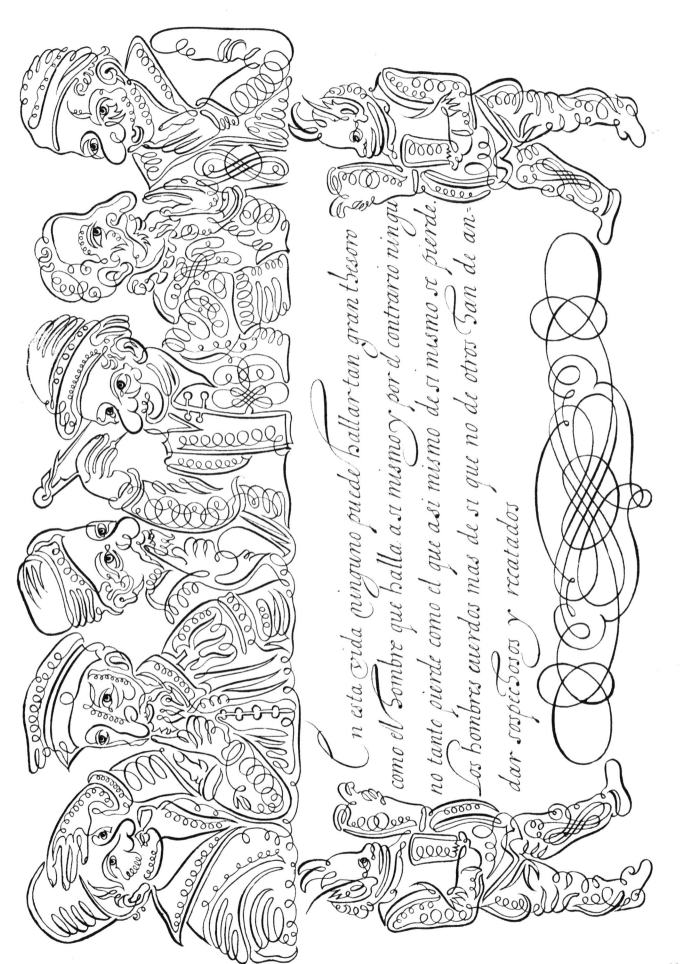

En esta vida ninguno puede hallar tan gran thesoro
como el hombre que halla a si mismo y por el contrario ninguno
no tanto pierde como el que a si mismo de si mismo se pierde.
Los hombres cuerdos mas de si que no de otros tan de an-
dar respectosos y recatados

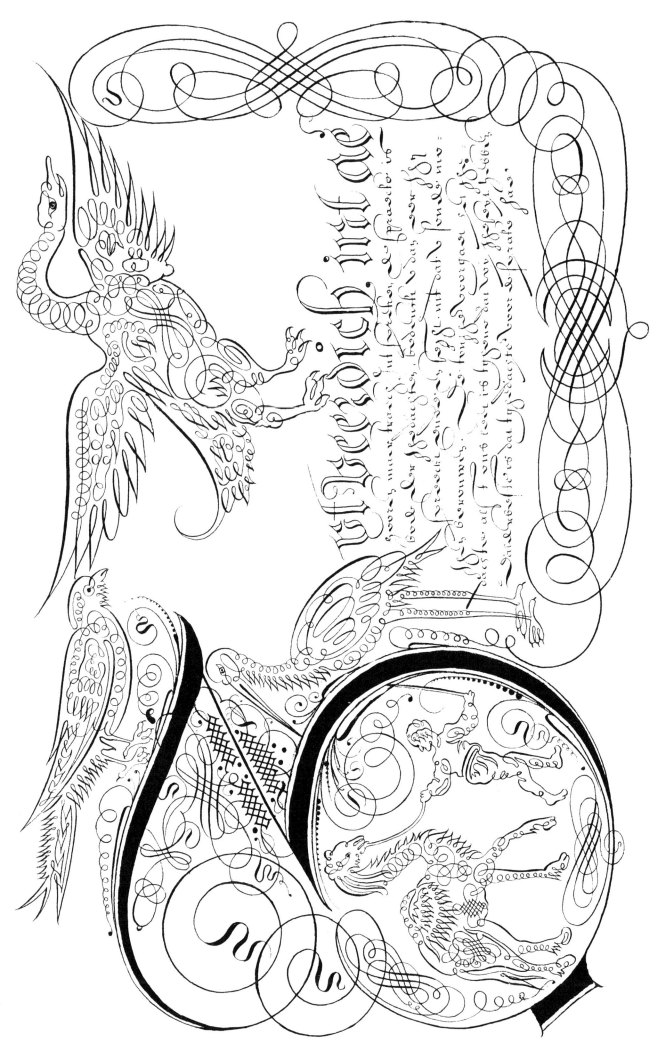

14

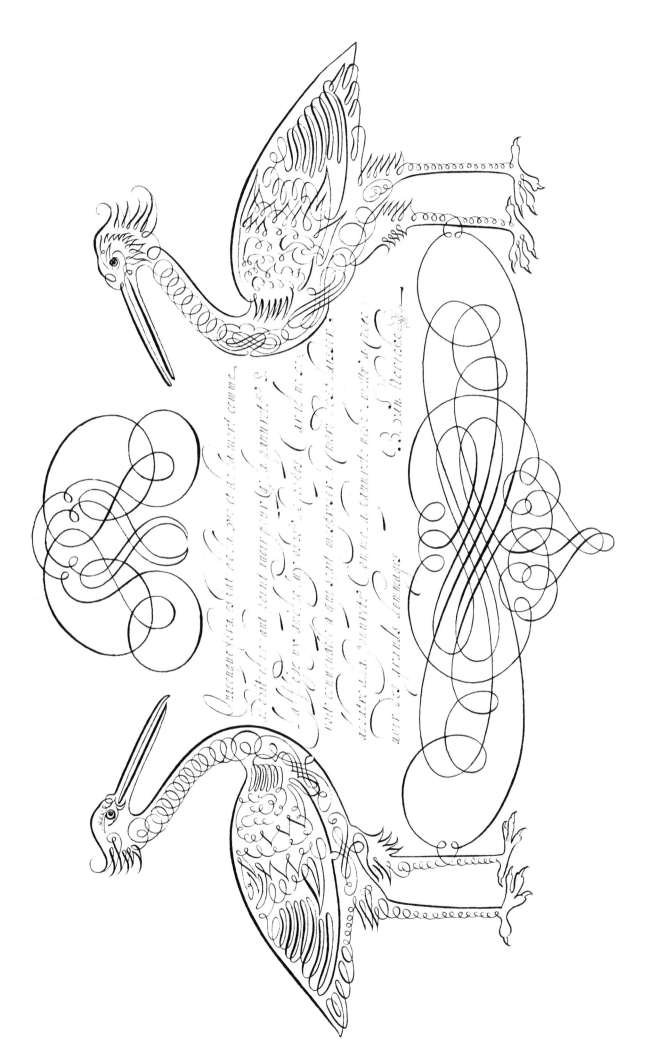

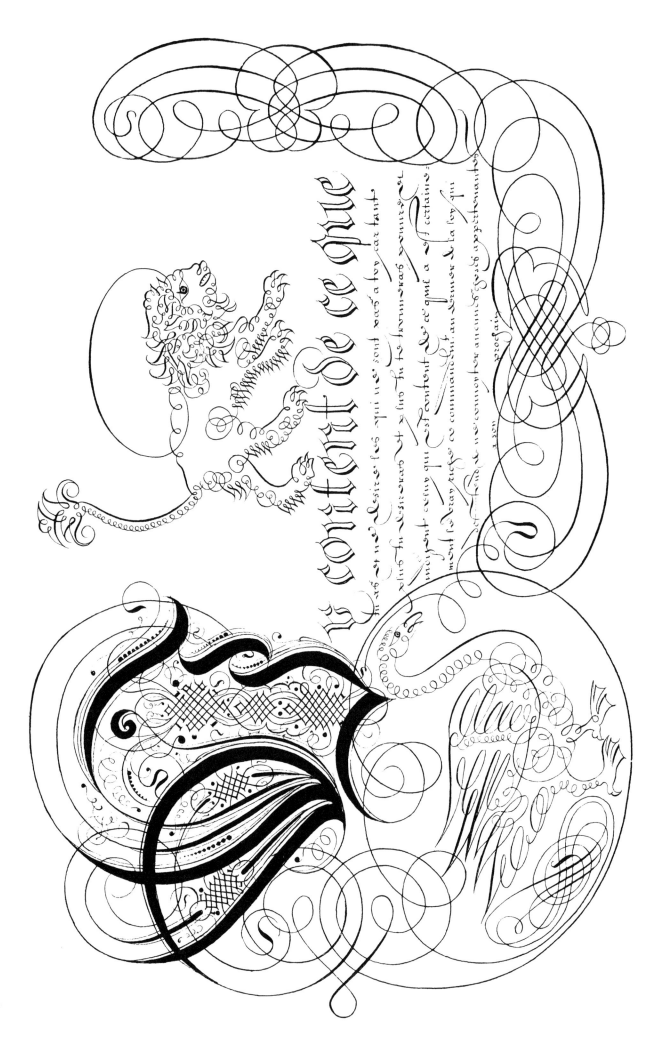

Le content de ce que

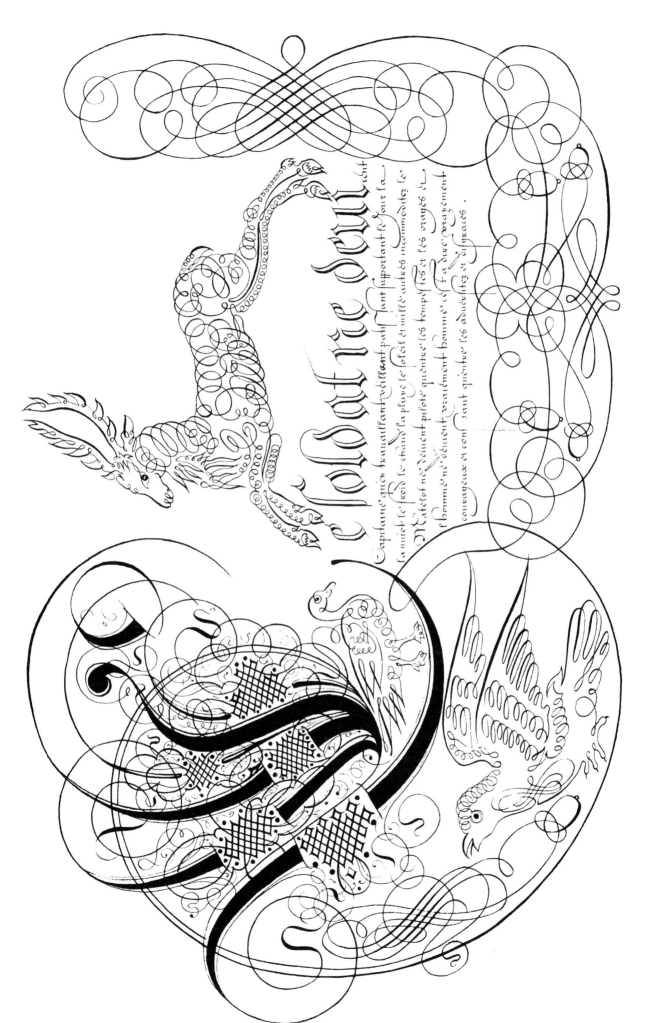

Capitaine quien trauaillant erreant paat sant suportant le Jour la
la nuict le froid le chaud la pluye le Soleil et mille autres incommoditez le
Matelot ne deuent pilote quiconue les temps frois et les orages et
l'homme ne deuent vraiement homme cest a dire veritablement
couragieux et constant quinter les aduersitez et disgraces .

17

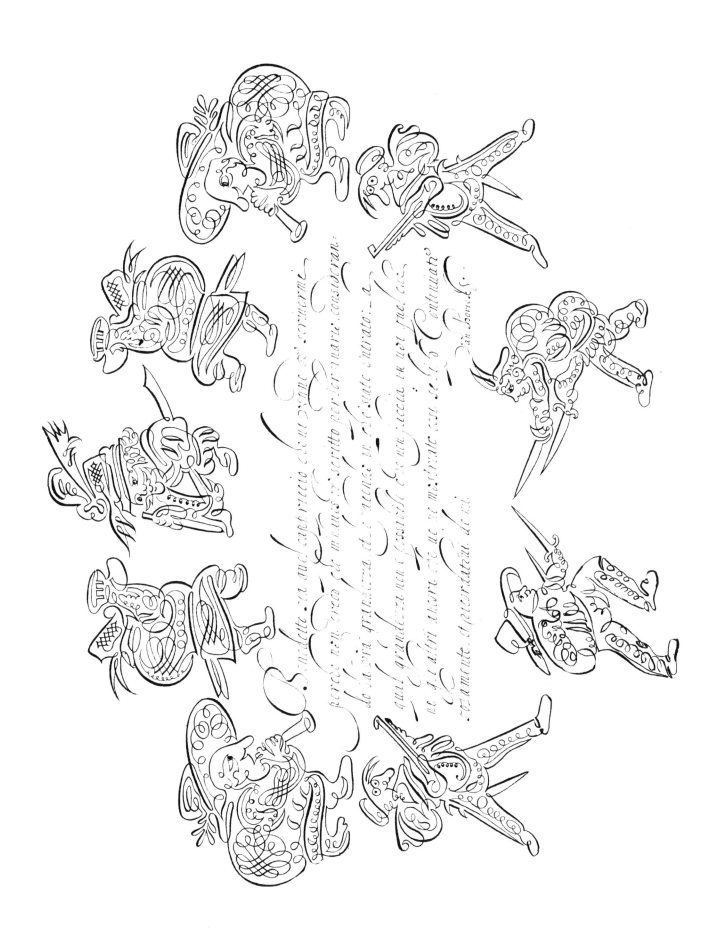

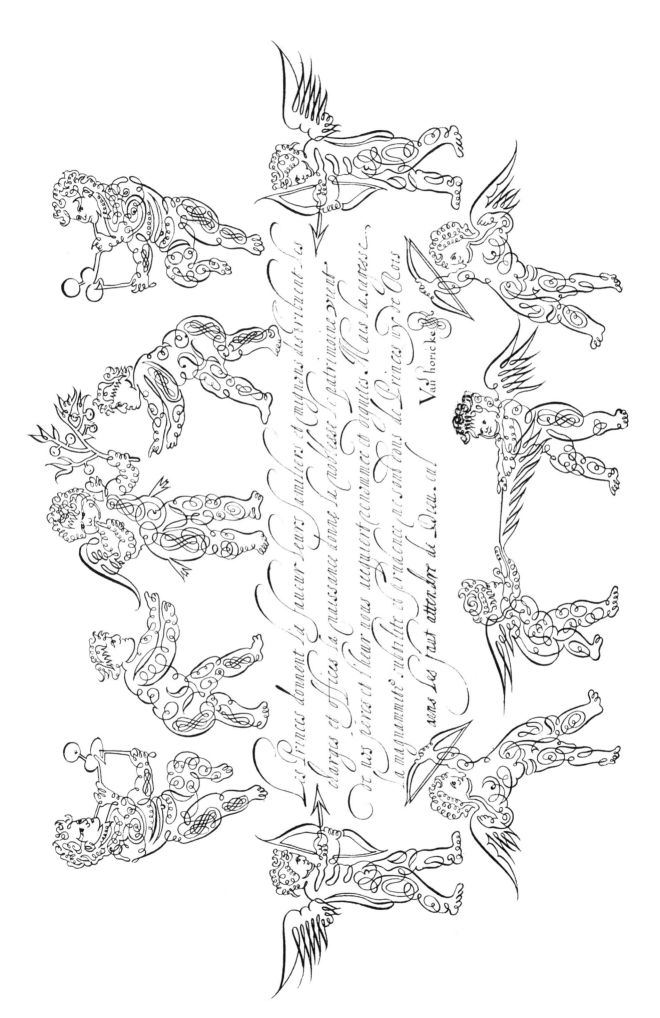

Les Princes donnent la faueur leurs familiers et mignons distribuent les
charges et offices la naissance donne la noblesse le patrimoine vient
de vos peres et l'heur vous acquiert cen somme et dignités Mais la sagesse
la magnanimité subtilité et prudence ne sont pas des Princes ny des Rois
sans les faut attendre de Dieu...ul

Van horicke

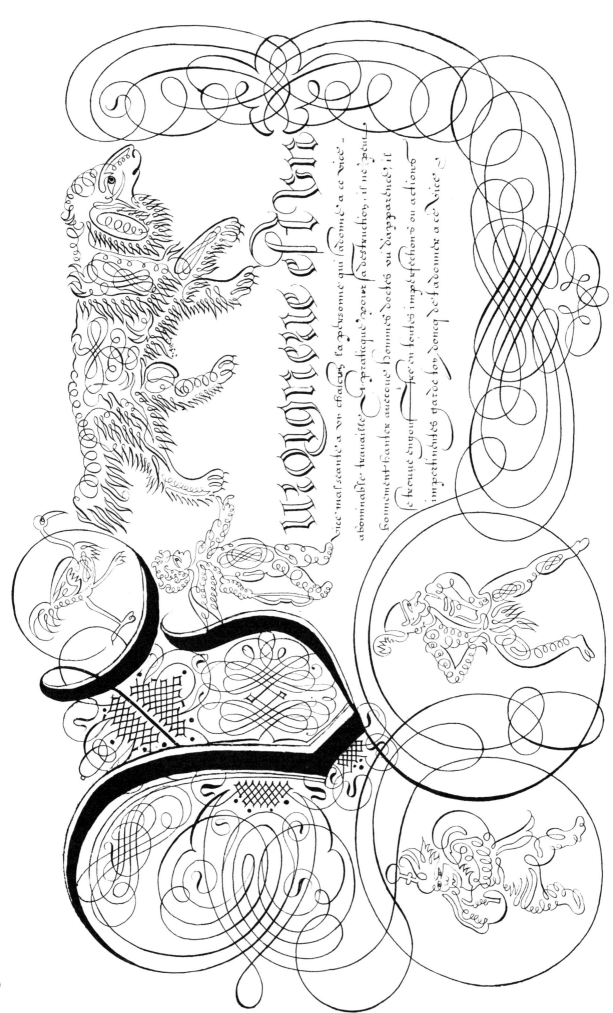

Ingratitude est Vn

vice malseante a vn chacun, la personne qui sadonne a ce vice
abominable trauaille et pratique pour sa destruction, il ne peut
bonnement hanter aueceue bonnes socté ou sapparchant, il
se trouue enjour ... en toutes imperfections ou actions
impertinentes grace sov donq de sadonner a ce vice.

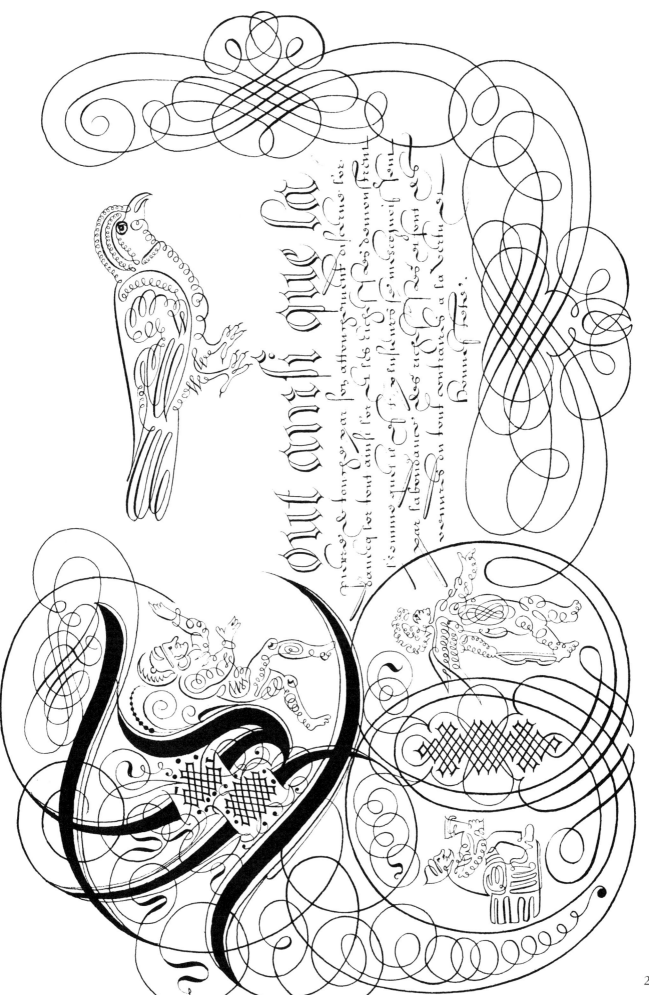

Sont amsi que sq

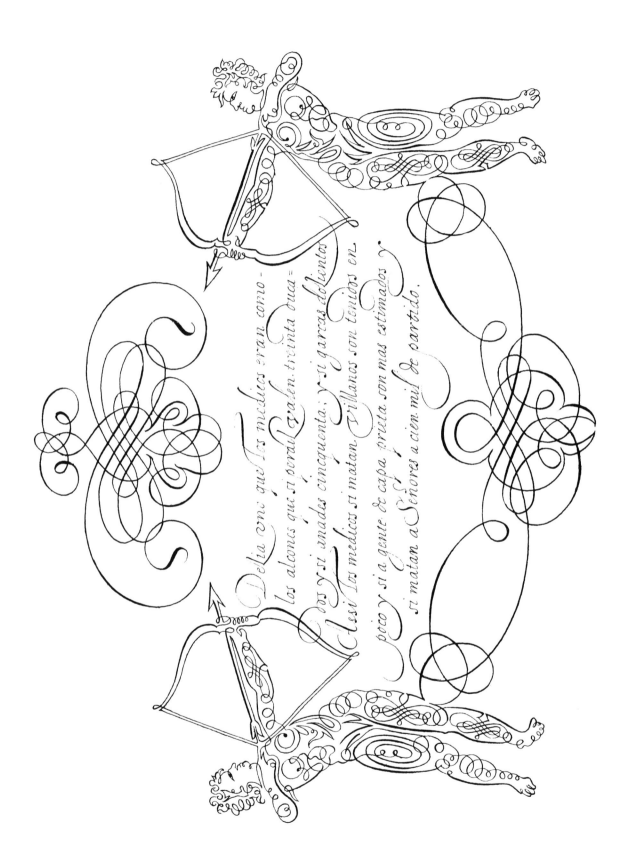

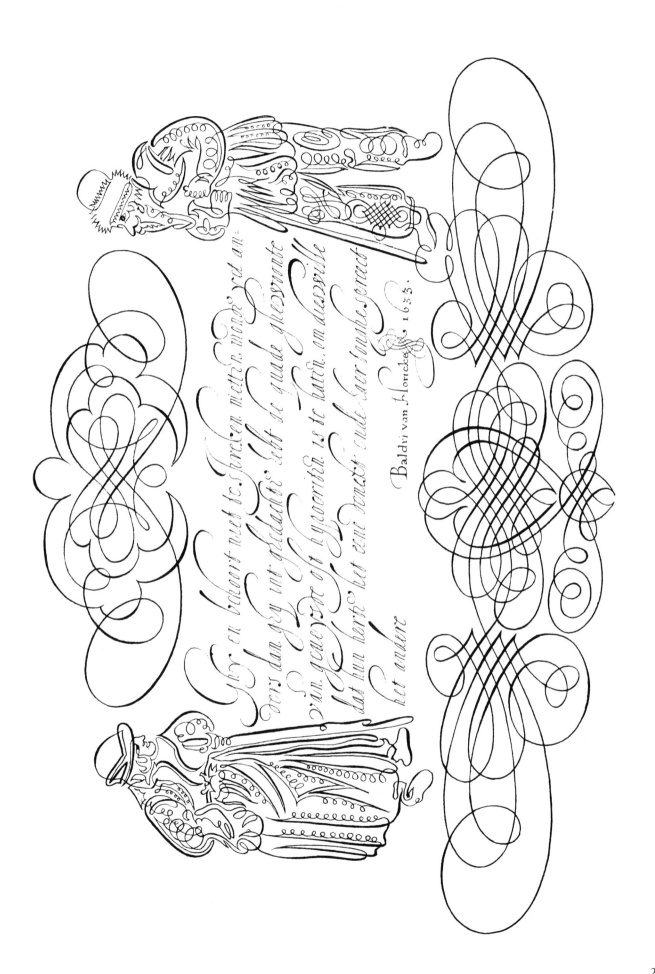

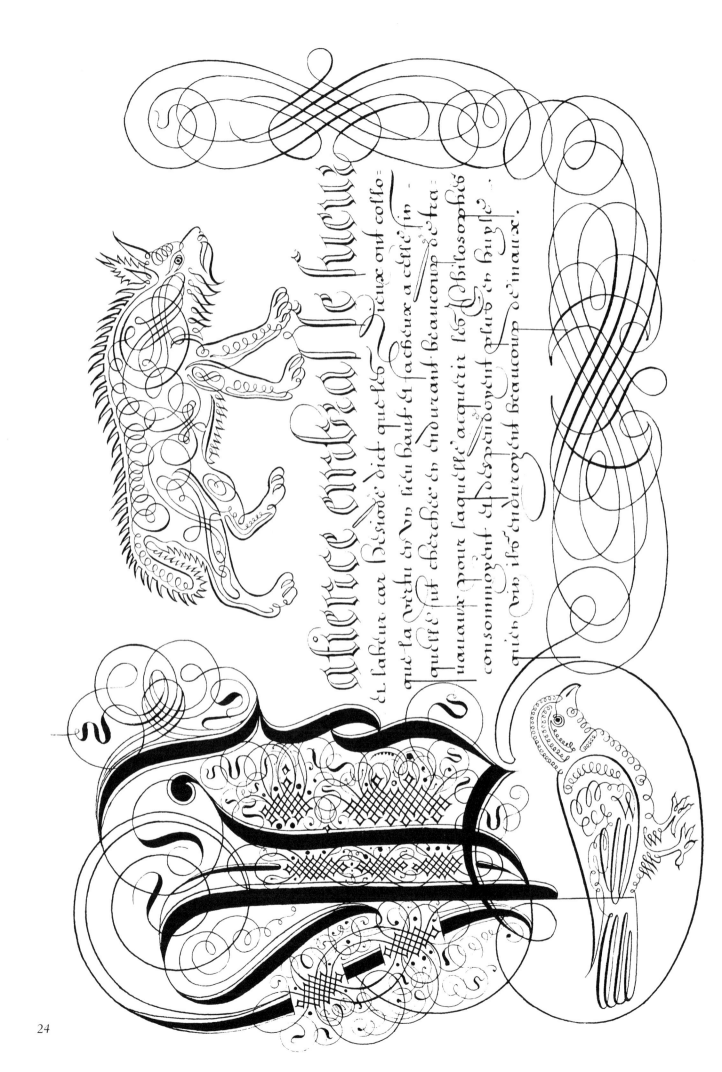

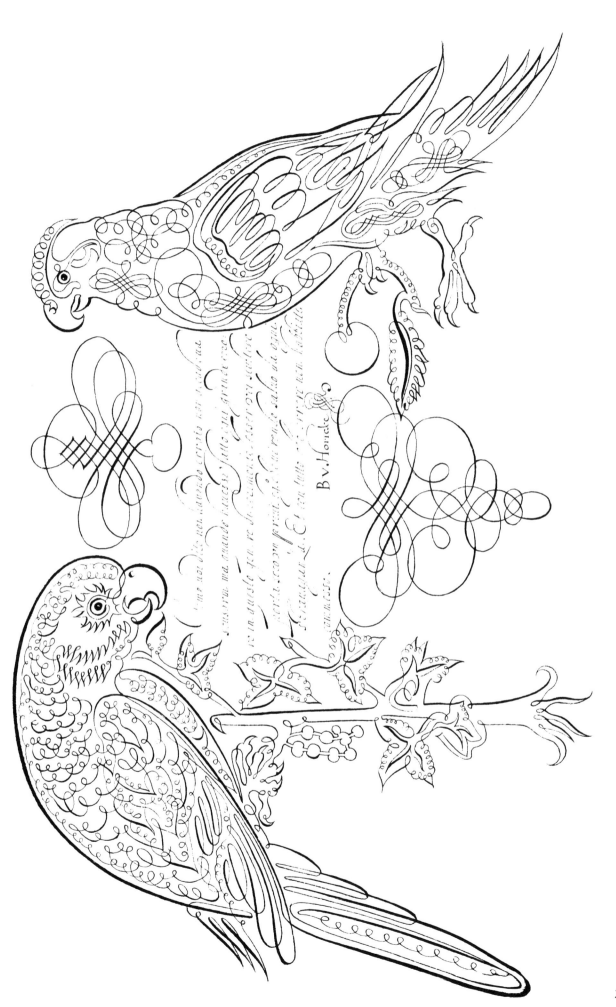

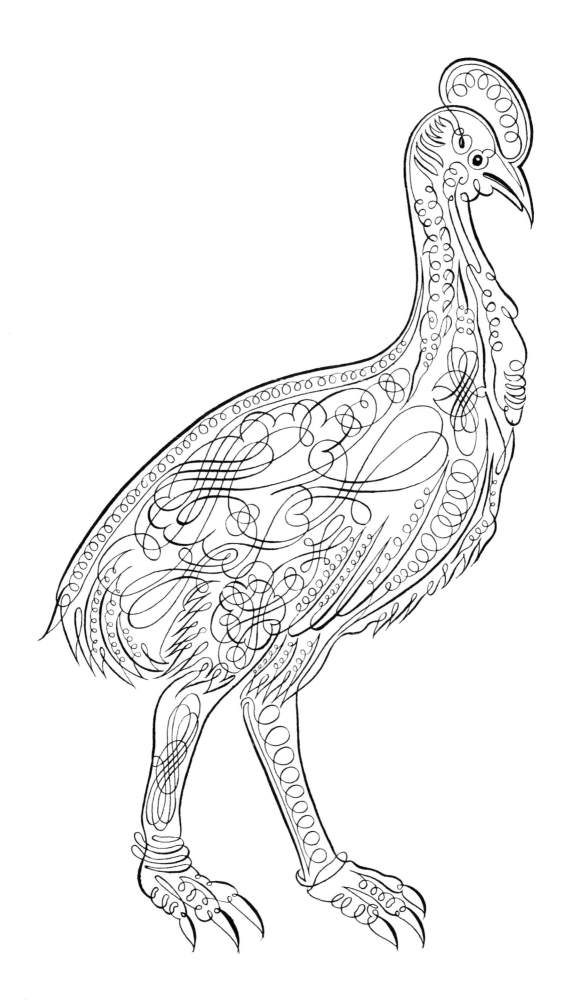

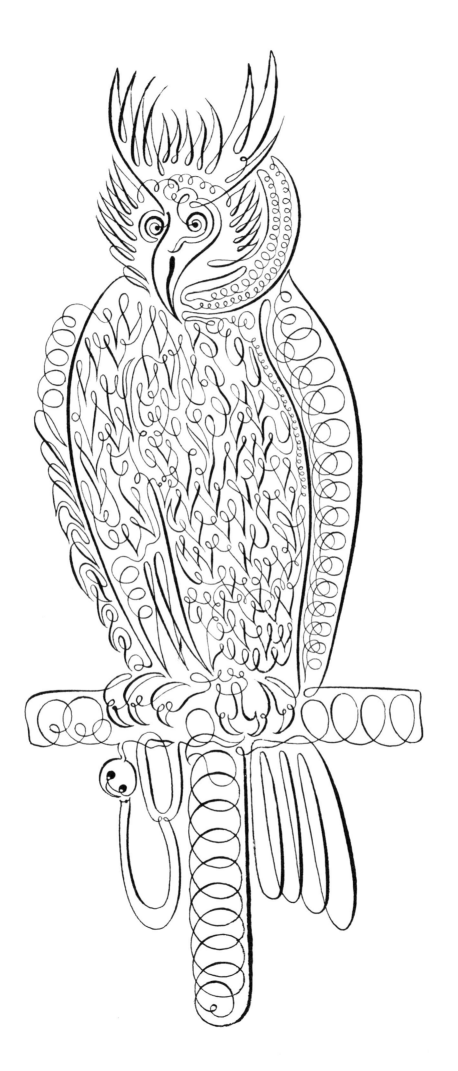

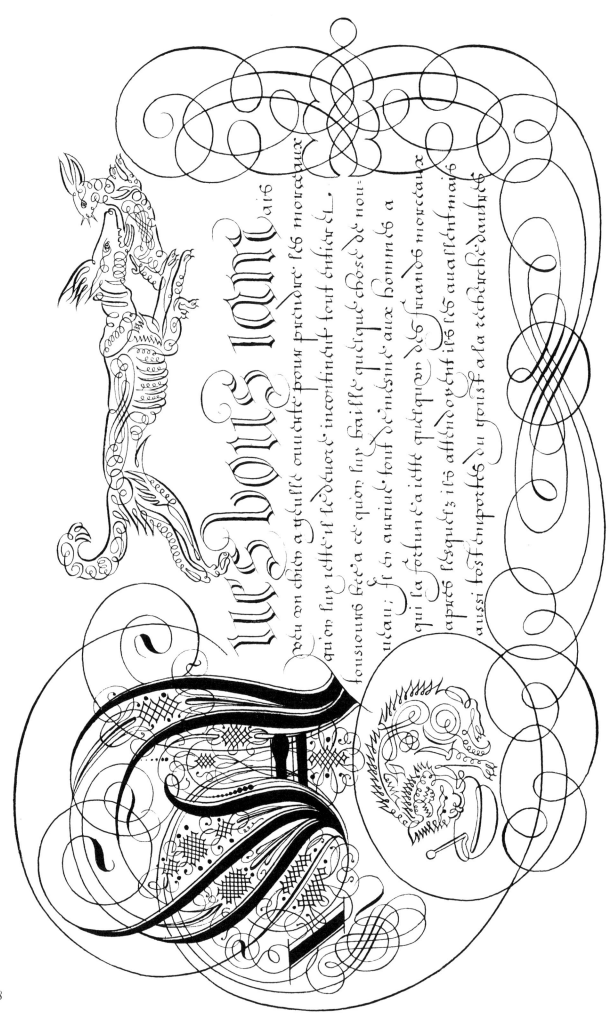

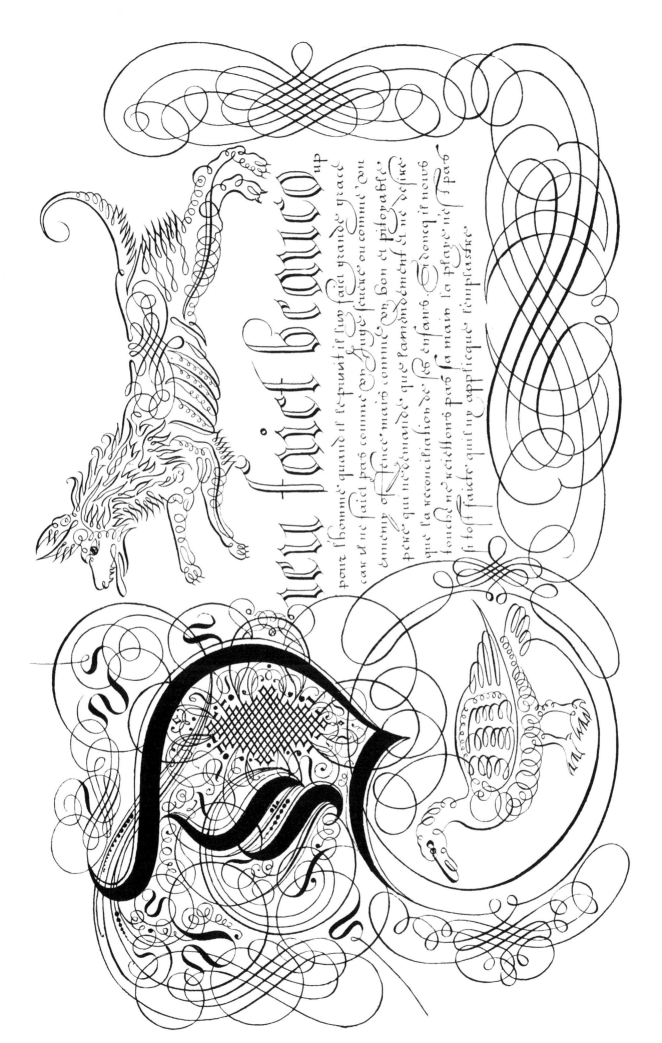

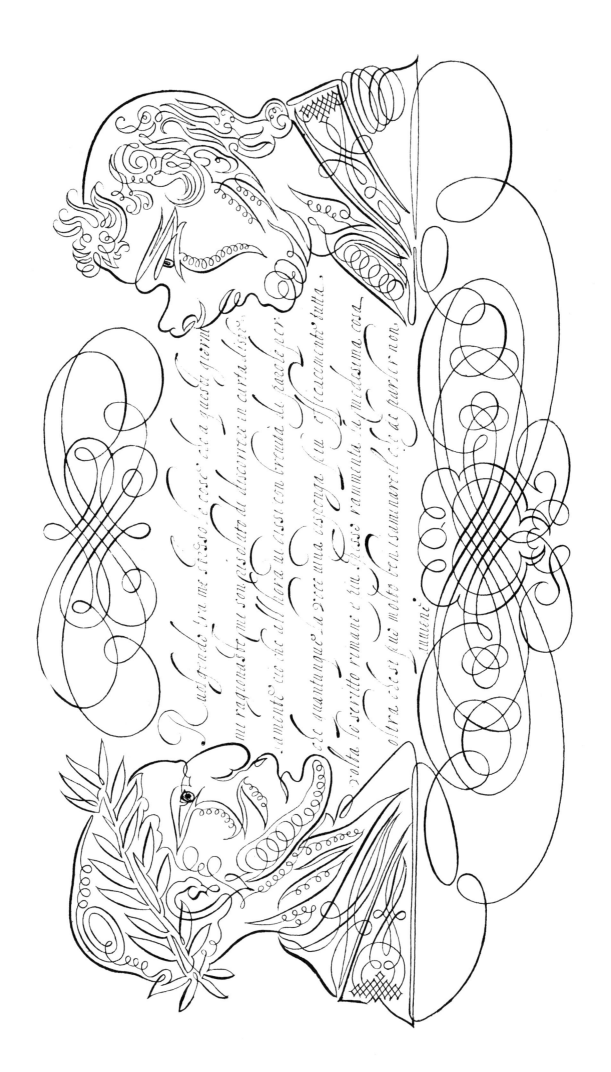

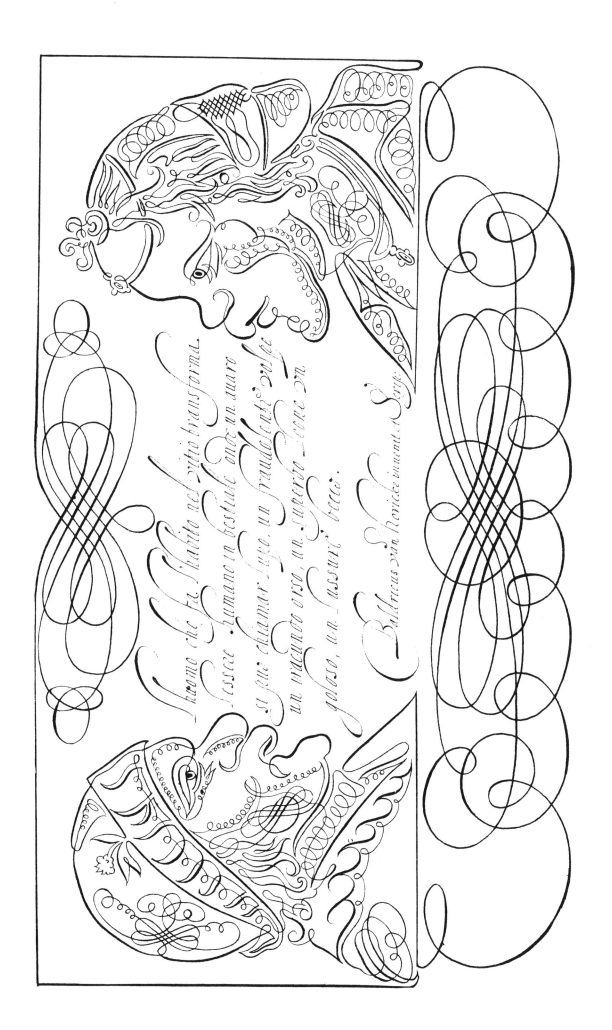

L'huomo che fa l'habito nel vitio transforma.
L'essere humano in bestiale; onde un auaro
si puo chiamar Lupo, un fraudolente Volpe,
un macinato orso, un superbo Leone ₒn.
golaso, un Lussurᵘ becco.

Balduinus van Hornicke inuentor et Scrip.

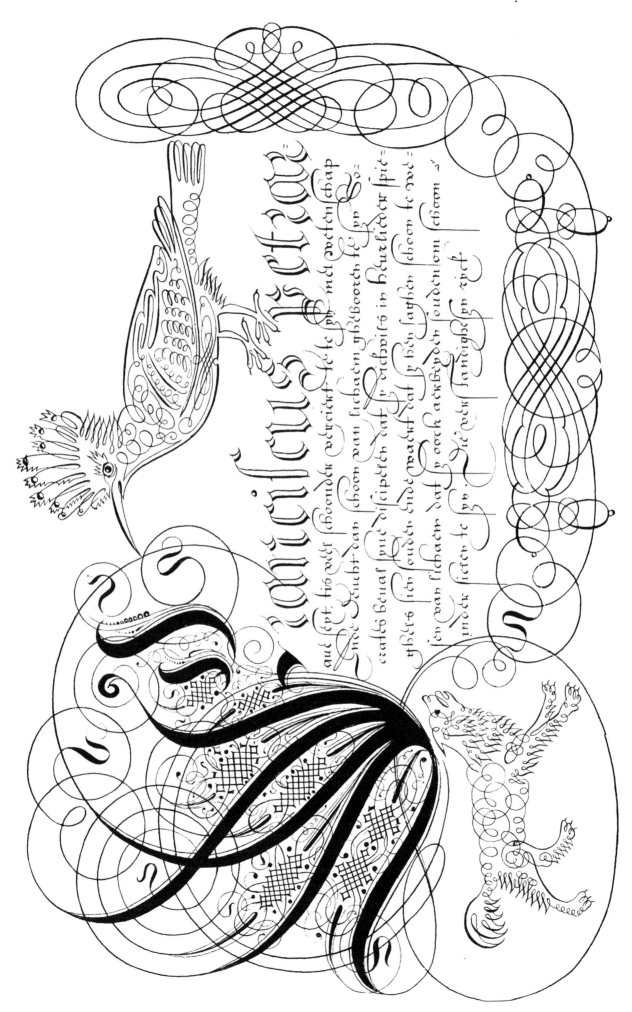

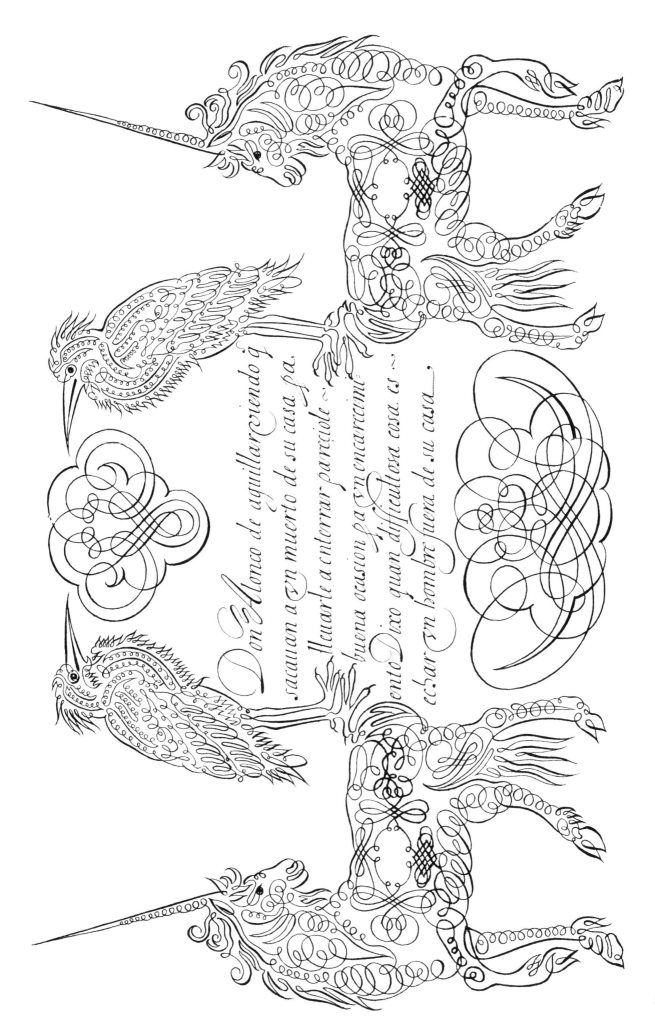

Don Alonso de aguillar siendo q
sacauan a un muerto de su casa pa.
lleuarle a enterrar paresçiole ~
buena orasion pa^a encarcam^a
ento Dixo quan difficultosa cosa es ~
echar un hombre fuera de su casa .

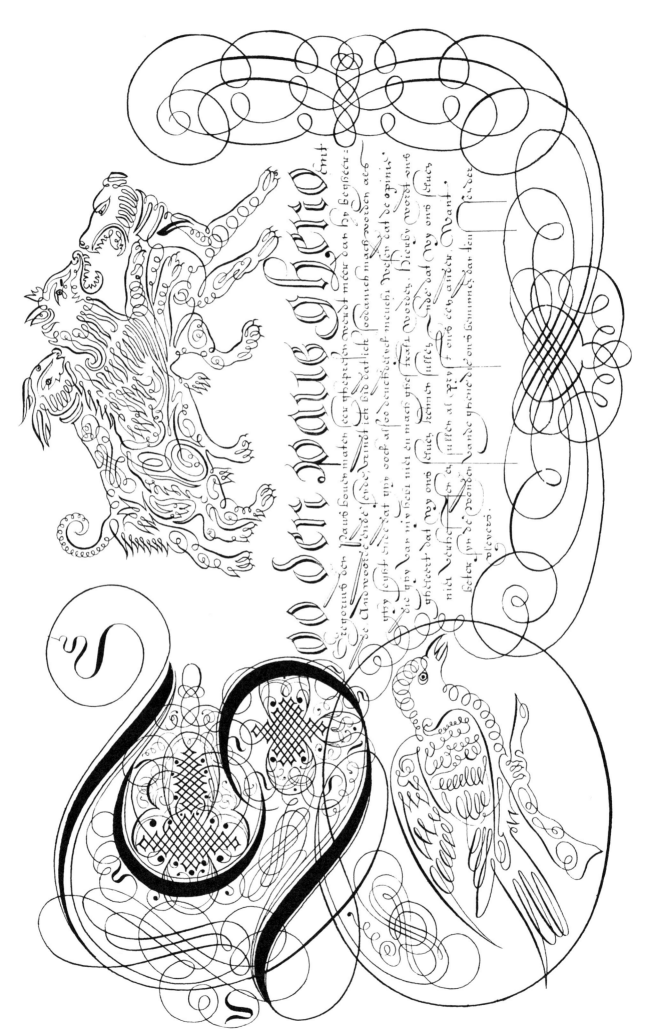

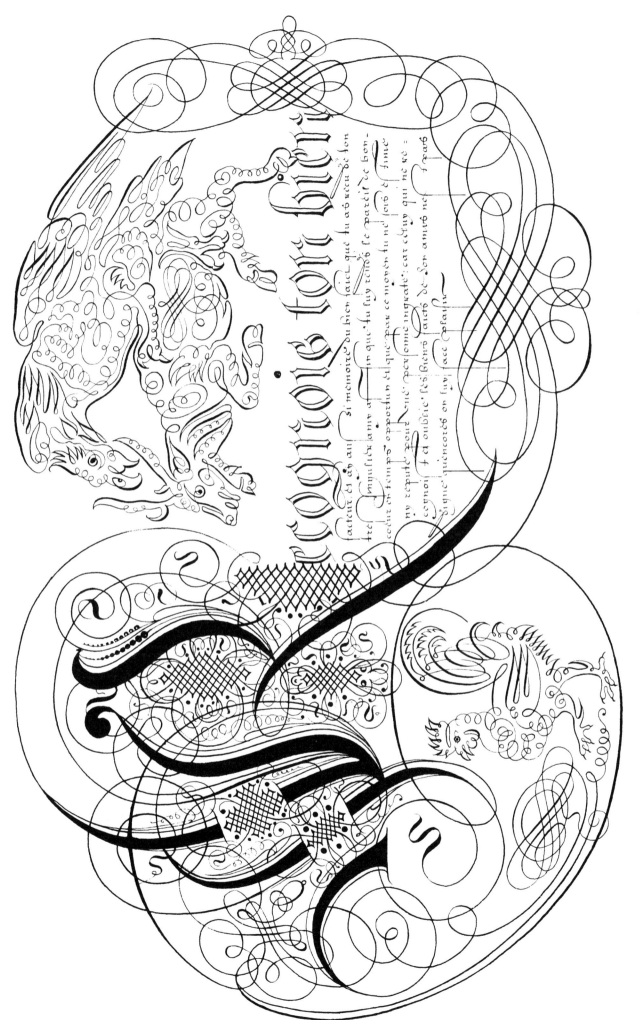

Cognoitz ton bien

facteur, et ay au si memoire du bien faict que tu as [...] de son
[...] [...] [...] en que tu luy rens le [...] de [...] de bon-
[...] en temps opportun alque par ce moyen tu ne [...] e [...]
[...] [...] [...] personne ingrate : car celuy qui ne re-
cognoit à oublié les biens faictz de son amis ne [...]
[...] quelconques en luy face plaisir.

35

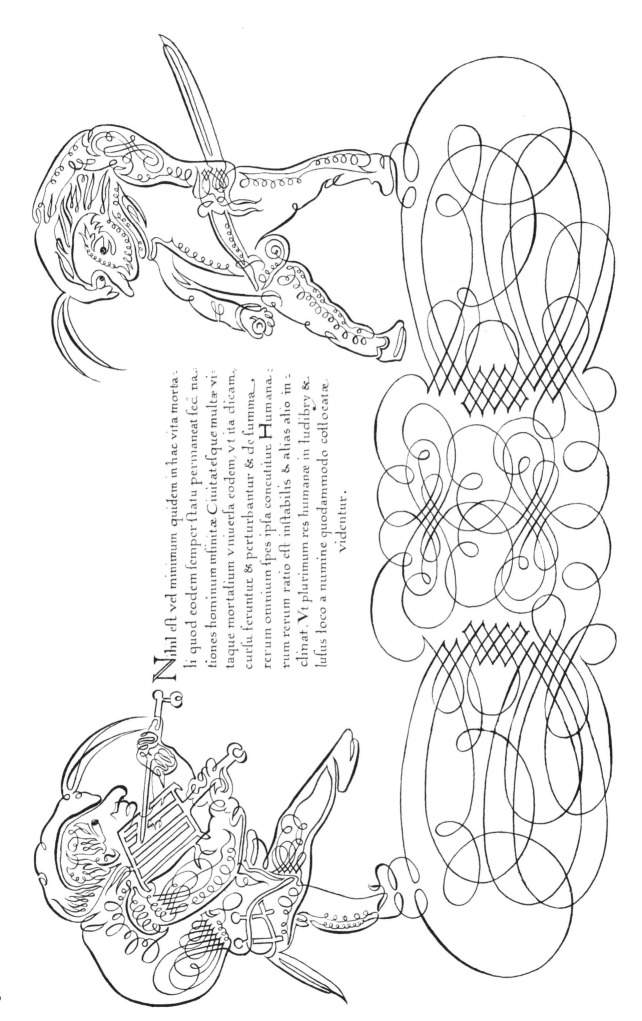

Nihil eſt vel minimum quidem in hac vita morta-
li quod eodem ſemper ſtatu permaneat ſec. na-
tiones hominum infinitæ Ciuitateſque multæ vi-
taque mortalium viuuerſa eodem, vt ita dicam,
curſu feruntur & perturbantur & de ſumma,
rerum omnium ſpes ipſa concutitur. Humana-
rum rerum ratio eſt inſtabilis & alias alio in-
clinat. Vt plurimum res humanæ in ludibry &
luſus loco a numine quodammodo collocatæ
videntur.

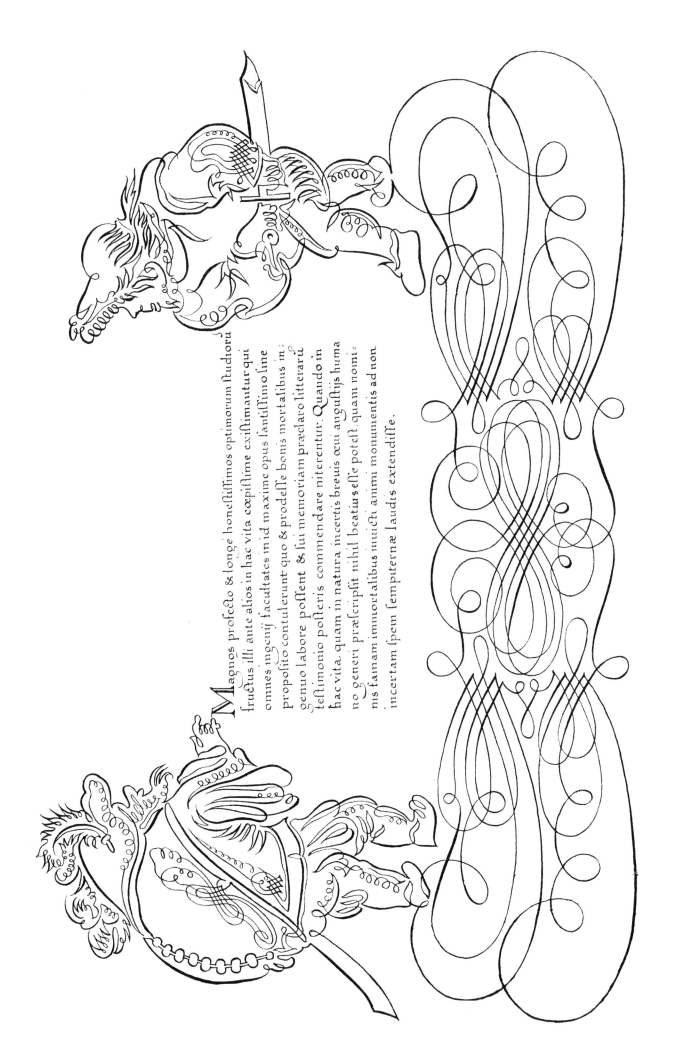

Magnos profecto & longe honestissimos optimorum studioru fructus illi ante alios in hac vita coepissime existimantur qui omnes ingenij facultates in id maxime opus sanctissimo sine proposito contulerunt quo & prodesse bonis mortalibus in: genuo labore possent & sui memoriam praeclaro litterarū testimonio posteris commendare niterentur. Quando in hac vita quam in natura incertis breuis ceui angustijs huma no generi praescripsit nihil beatius esse potest, quam nomi: nis famam immortalibus inuicti animi monumentis ad non incertam spem sempiternae laudis extendisse.

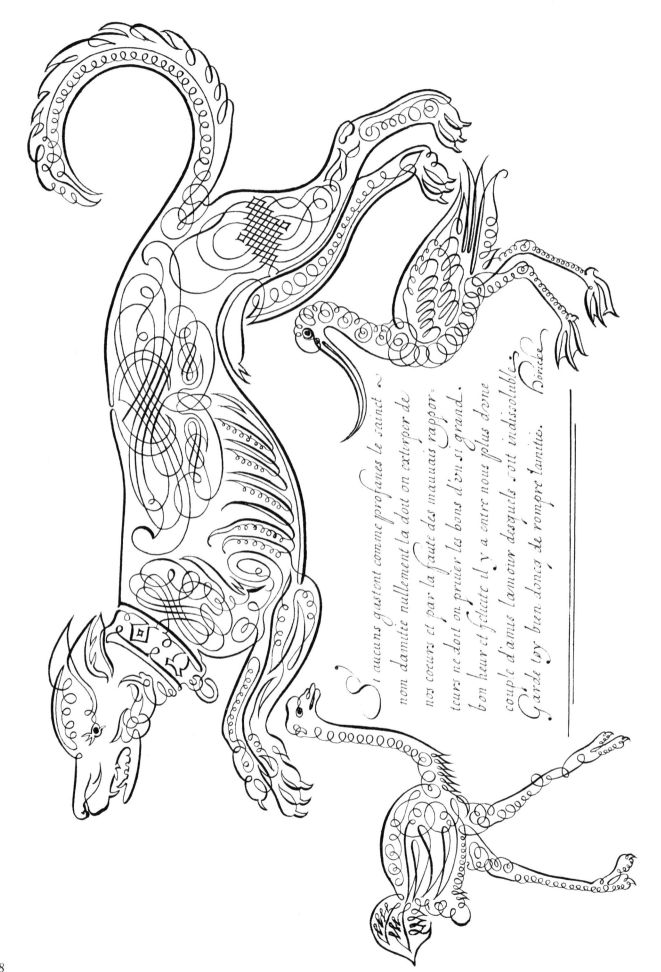

Si aucuns gustent comme profanes le sainct
nom d'amitie nullement la doit on extirper de
nos cœurs et par la faute des mauuais rappor=
teurs ne doit on priuer les bons d'vn si grand
bon heur et felicite il y a entre nous plus d'vne
couple d'amis l'amour desquels est indissoluble.
Garde toy bien donc de rompre l'amitie. Periçle

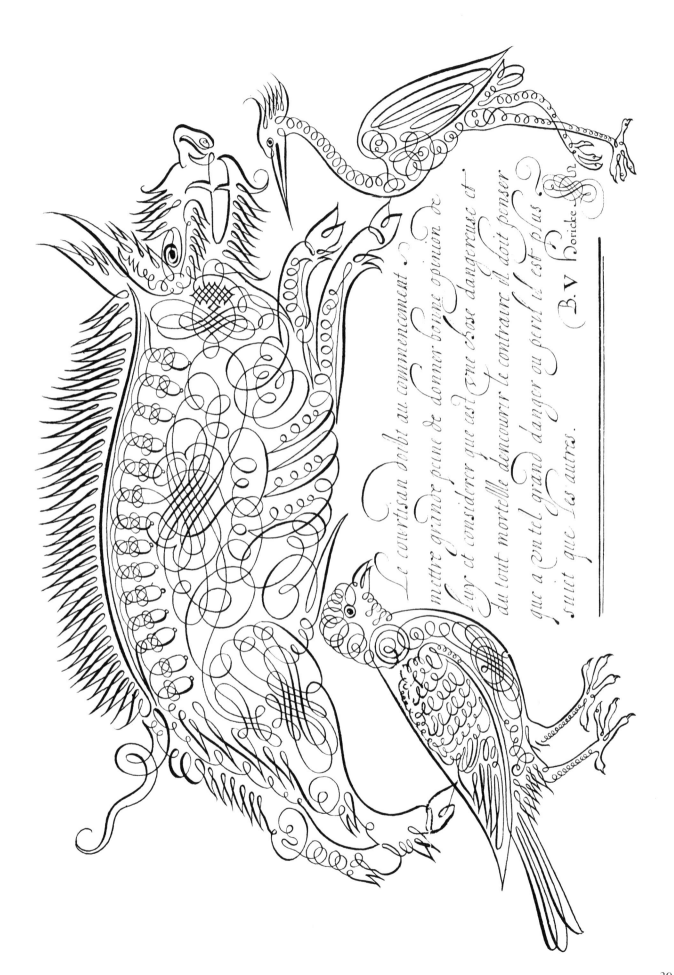

Le courtisan doibt au commencement
mettre grande peine de donner bonne opinion de
Luy, et considerer que cest que chose dangereuse et
du tout mortelle descouvrir le contraire il doit penser
que a en tel grand danger ou peril il est plus
suiet que les autres.

B. v Doricke.

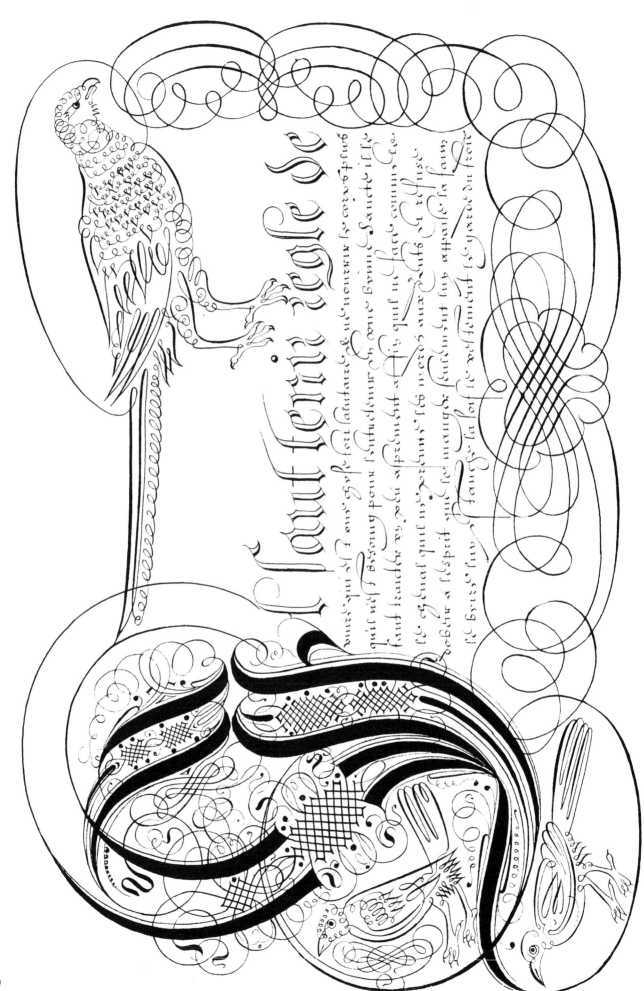

40

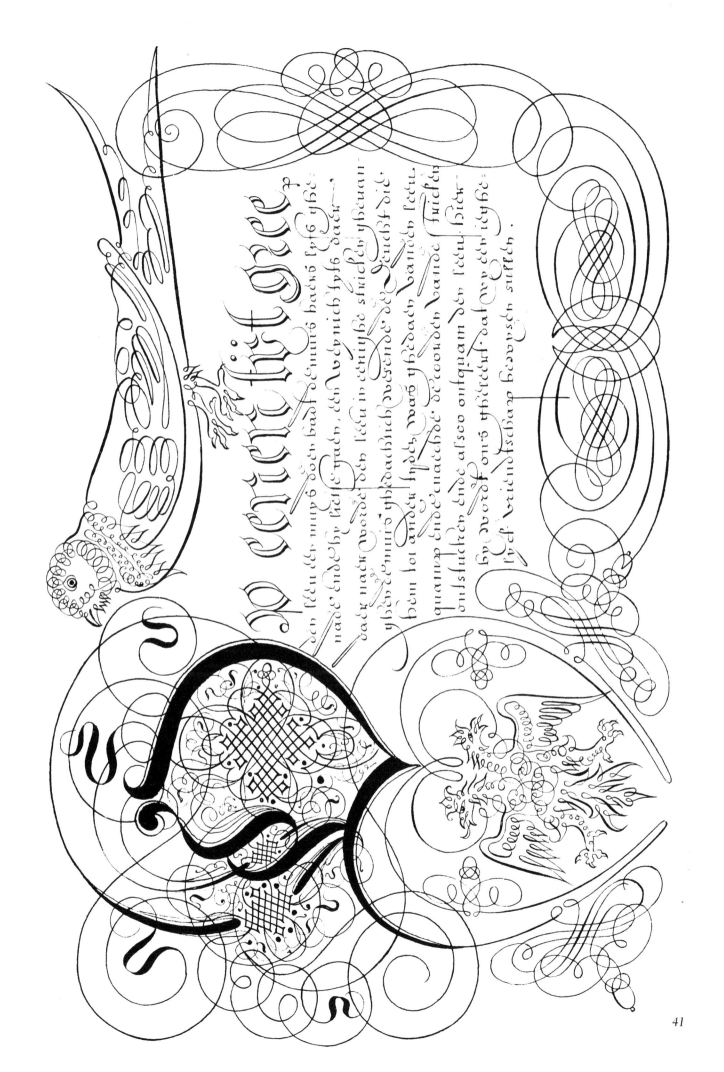

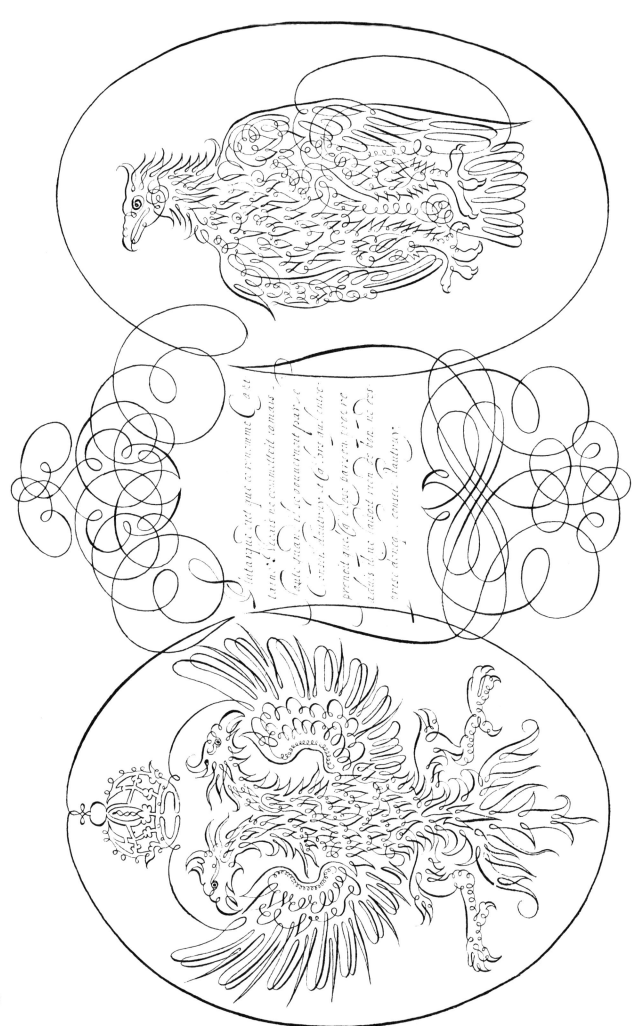

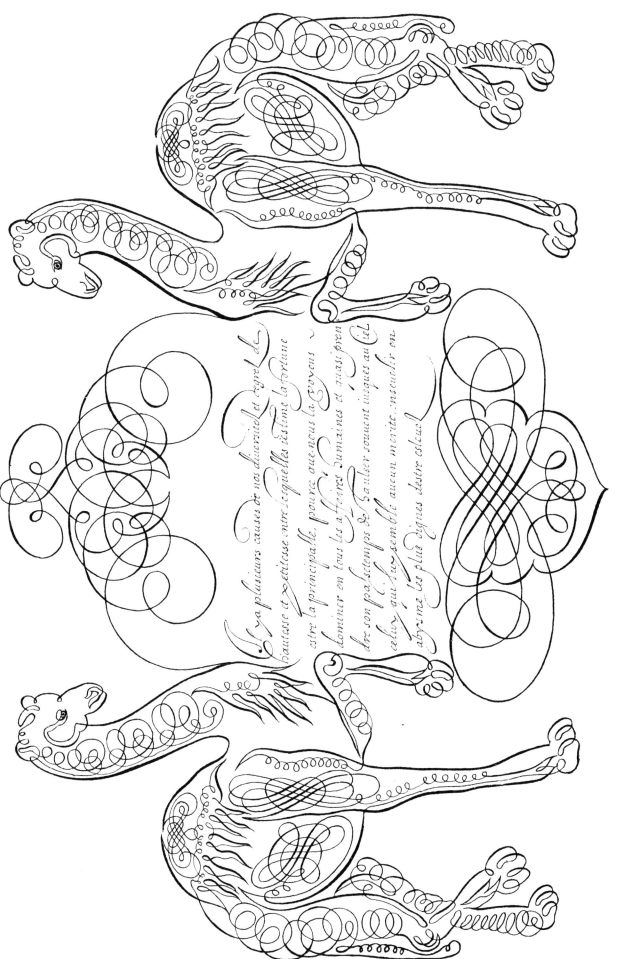

Il y a plusieurs causes de nos douleur et regret de
haultesse et tristesse entre lesquelles j'estime la fortune
estre la principalle, pource que nous la trouvons
dominer en tous les affaires humaines et quasi pren-
dre son passetemps de haulser souvent jusques au ciel
celuy qui luy semble aucun merite, insuculer en
abysme les plus dignes destre esleuz

43

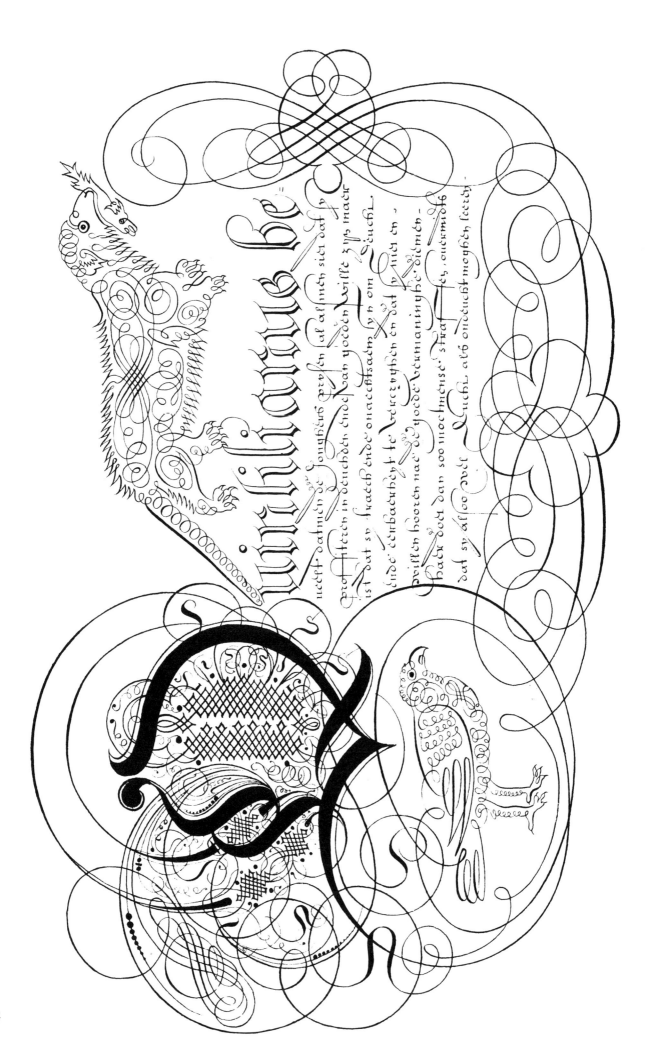

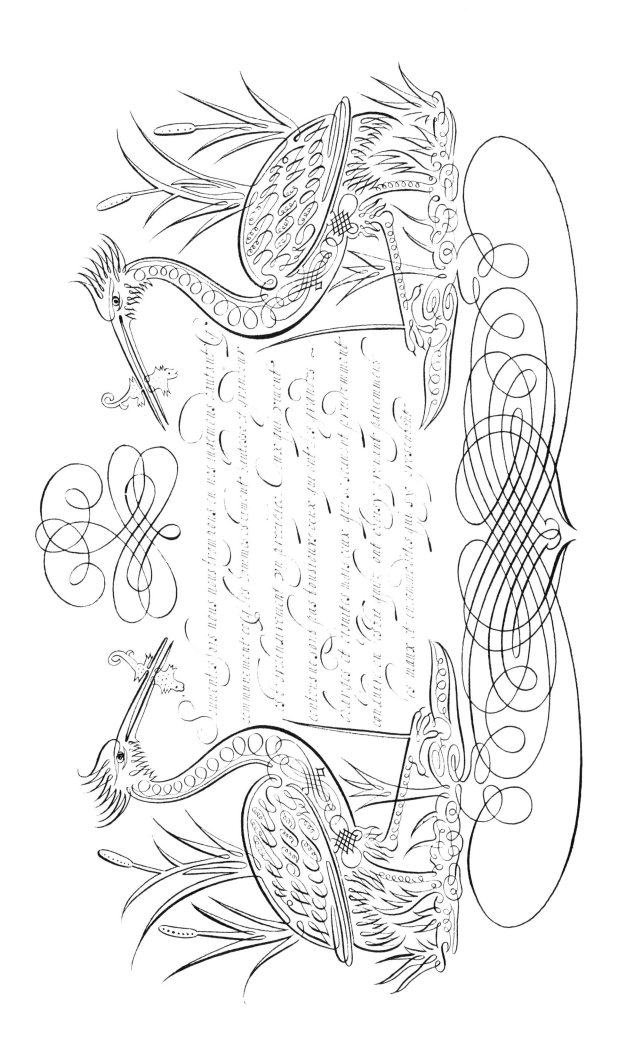

45

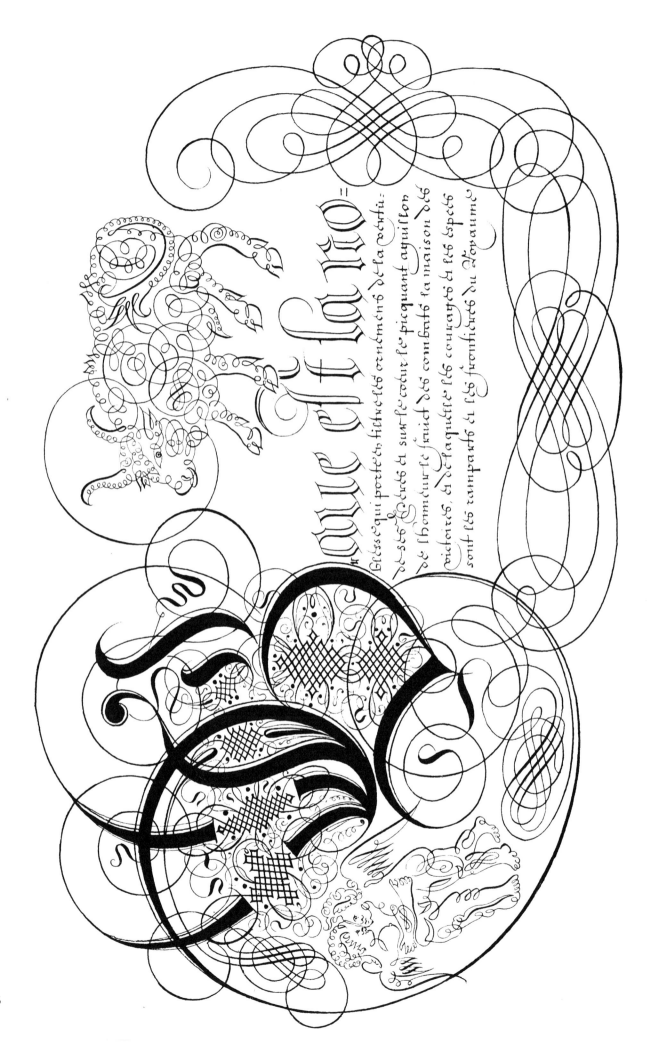

ᛒᛒGlosse qui prete les filets des ornements de la vertu:
ᚢᚢᚢᚢ Cyrés et sur le cœur le piquant aguillon
De l'honneur le fruict des combats la maison des
victoires, et de laquelle les couragés et les espes
sont les rampars et les frontières du Royaume,

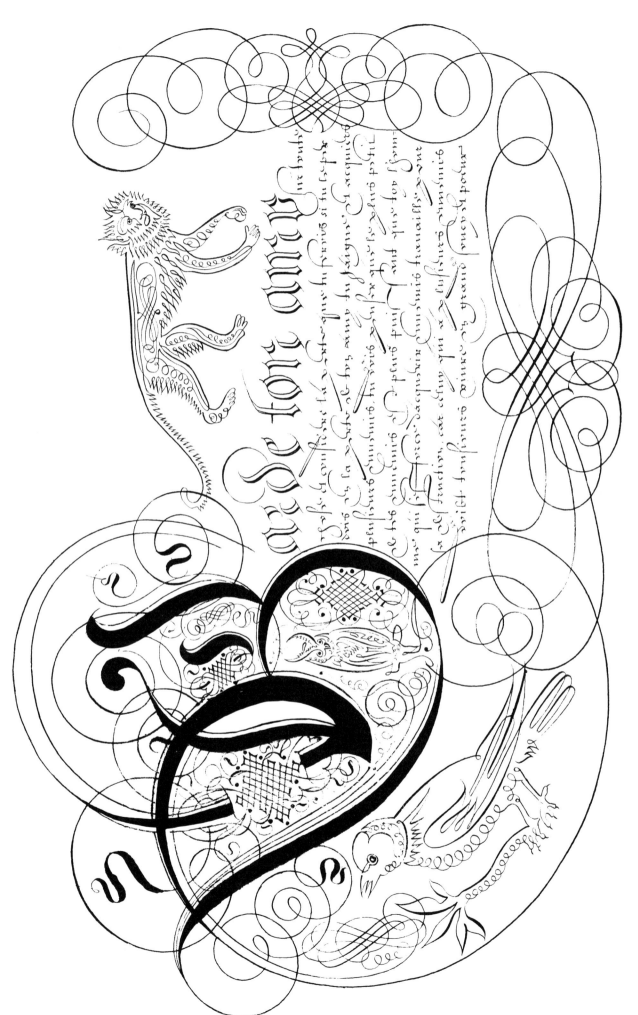

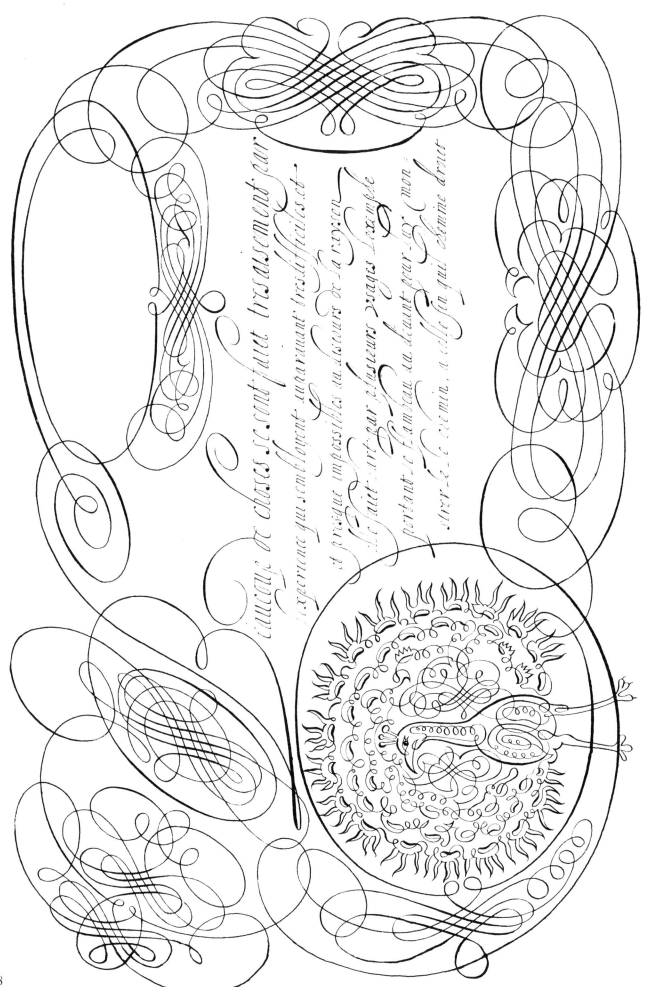

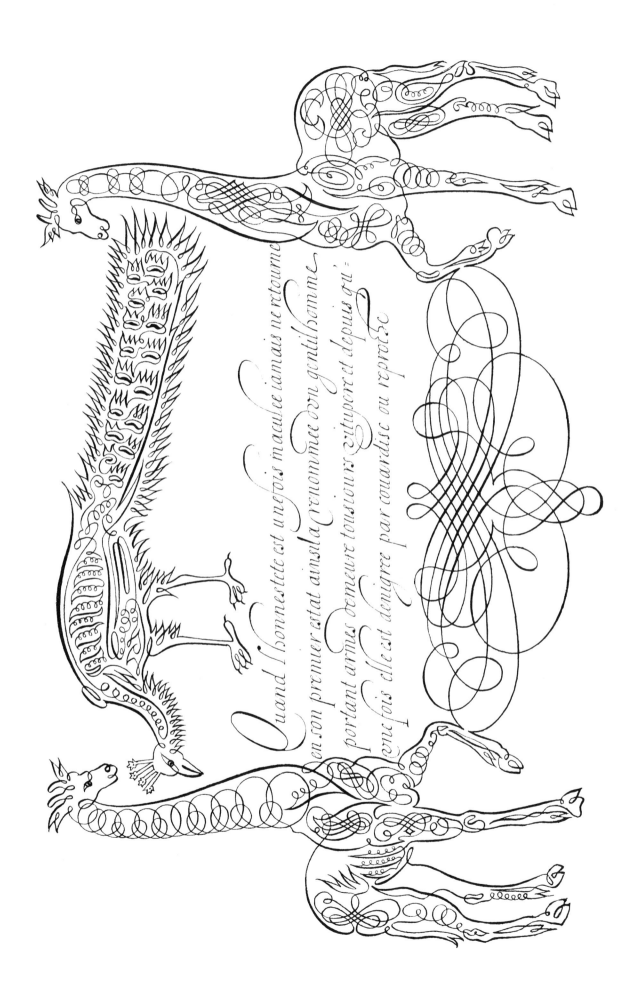

Quand l'honnesteté est une fois maculee iamais ne retourne
en son premier estat ainsi la renommee d'ung gentilhomme
portant armes demeure tousiours estimee et depuis qu'
une fois elle est denigree par couardise ou reproche.

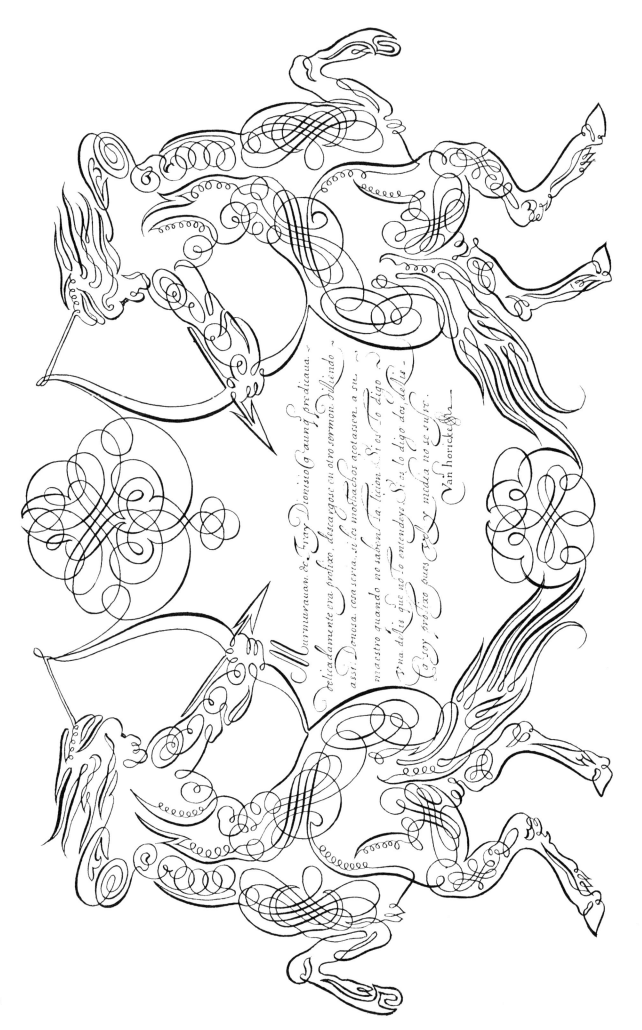

Murmurauan de Fray Dionisio q̃ aunq̃ predicaua
delicadamente era prolixo, descargose en otro sermon diciendo
assi. Dioñsa cosa seria...su los mochachos açotassen. a su.
maestro quando no sabran la licion. Si os lo digo
vna deflis que no lo entendeys. Si es lo digo dos de flis
Callos prolixo pues q̃ dos y media no se sufre.
Van horickessa.

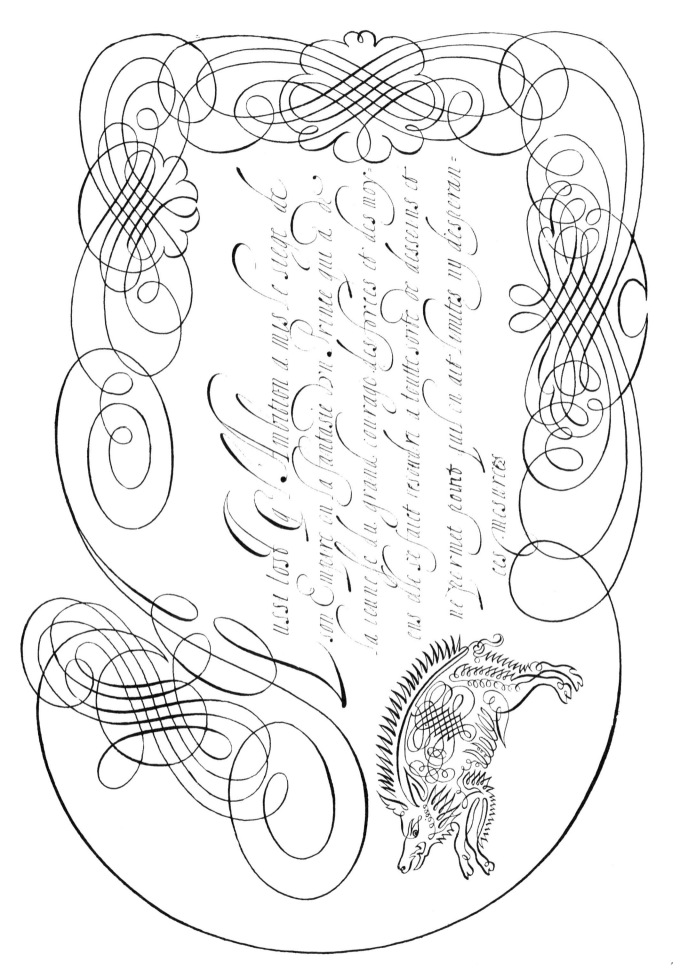

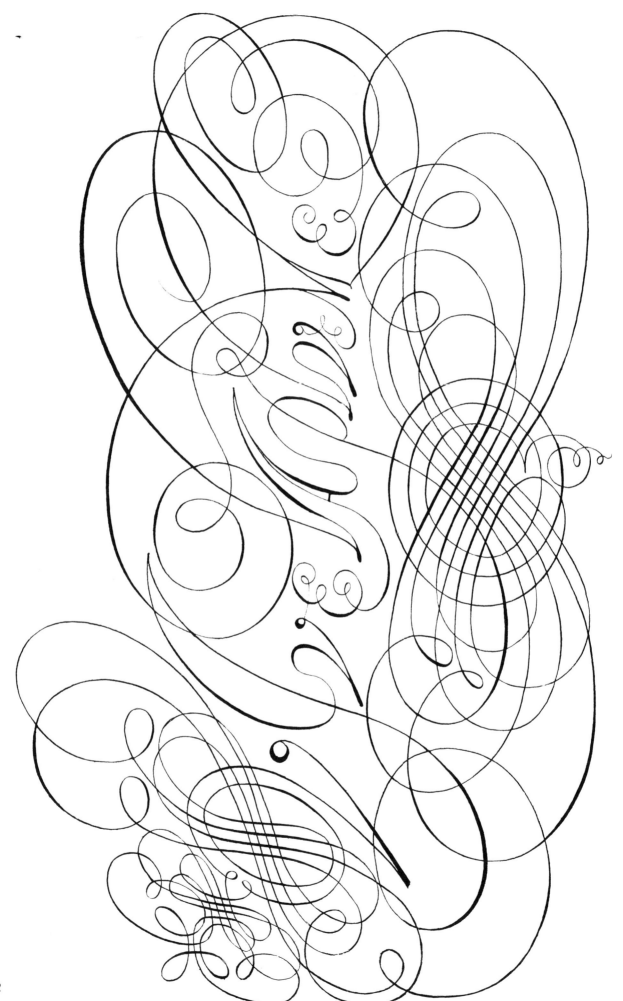